Le Petit Prince

小 王 子

行 星 漫 遊 著 色 本

中 英文版

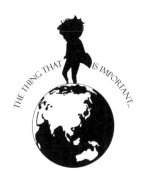

THE THING THAT IS IMPORTANT...

安東尼·聖修伯里　著

Bunny　繪

葉實琥　譯

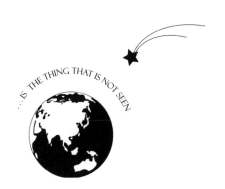

...IS THE THING THAT IS NOT SEEN

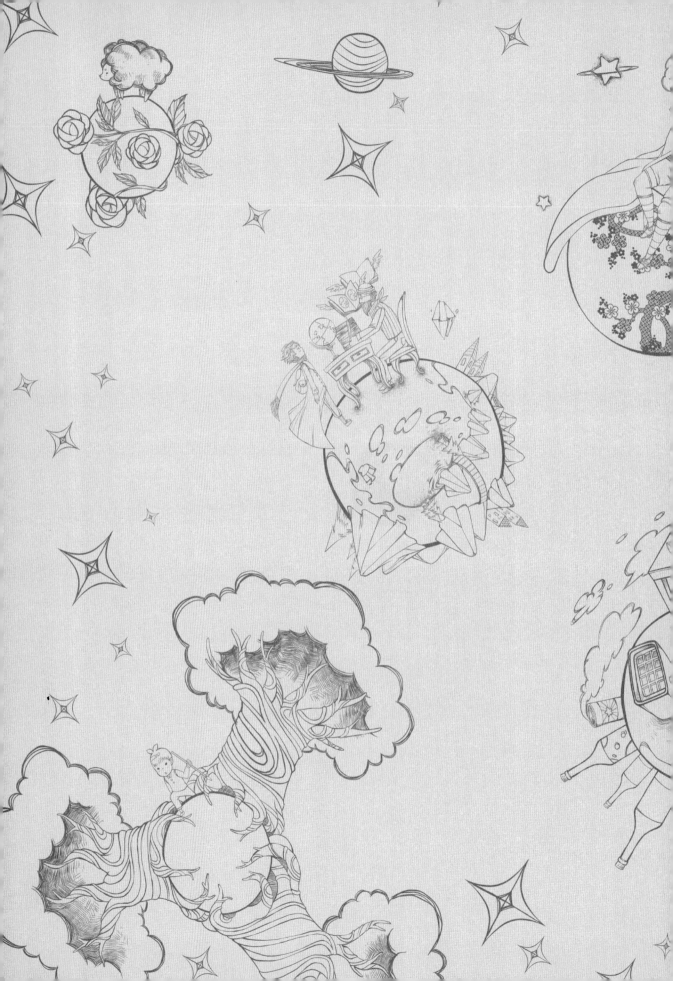

獻 給 萊 翁 · 維 爾 特

請所有讀這本書的孩子們，原諒我把這本書獻給一位大人。

我有一個很合理的理由：他是我在這個世界上最好的朋友。

我還有另一個理由：這位大人什麼都懂，甚至懂孩子的書。

我還有第三個理由：這個人住在法國，他在那裡飢寒交迫需要安慰。

如果這些理由還不夠充分，

我願意把這本書獻給兒時的他。

所有大人都曾是小孩，雖然很少人記得這一點。

因此，我要把獻詞改成：

獻給小男孩

萊翁 · 維爾特

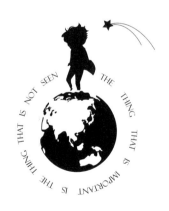

Chapter 1

　　六歲的時候，有一次，我在一本介紹原始森林的書——《往日真實故事集》，看到一張美麗而奇特的畫，描繪一隻蟒蛇正在吞噬一隻野獸。下圖是那張畫的複寫。書上描述：「蟒蛇連一口都沒有咀嚼，就把獵物整個吞下去，接著，一動也不動地長眠六個月，緩慢地消化肚子內的食物。」那時，我反覆思索叢林所發生的這類怪事，接著，輪到我出手。我拿起一支彩色鉛筆，完成我生平第一幅畫作。我人生的第一號畫作長這樣……

我把我嘔心瀝血的創作拿給大人看，問他們看起來是否很可怕。

但是，他們回答我：「一頂帽子怎麼會可怕？」

我並不是在畫一頂帽子，而是一隻蟒蛇正在消化一隻大象。為了使大人了解我的畫作，我畫出蟒蛇的剖面圖。沒辦法，大人總是需要再三解釋。總之，我人生的第二號畫作長這樣……

最後，那些大人勸我放棄這兩張看得見內部與看不見內部的蟒蛇畫作，把興趣轉移到地理、歷史、算術和文法上。

於是，六歲的我放棄了美好的志願——畫家。我人生的第一號畫作和第二號畫作，未得到符合期望的成功，使我非常灰心。大人不曾快速理解一件事，必需叫人為他們一遍又一遍地說明，對孩子來說，這真是件令人疲倦又沮喪的事。

因此，我不得不選擇另外一個職業，我學會駕駛飛機。世界上的各個角落我幾乎都飛過了，沒錯，以前學的地理對我很有用，我只要睜眼觀察，即可分辨此處是中國還是亞利桑那。這技能在我獨自於夜晚迷路時，非常有幫助。

於是在我的一生中，我和一大堆一板一眼、堪稱「正經」的人有了密切的往來。我長期生活於大人的世界，仔細地觀察他們，卻不曾改變對他們的觀感。

當我覺得自己遇見一位看起來較賢明的大人，我會拿出我隨身攜帶的第一號畫作，試一試他。我想知道他是否真的有理解力，但這樣的人經常會回答：「這是一頂帽子。」

若是如此，我便不再跟他談論蟒蛇，不談論原始森林，也不跟他談論星星。我遷就他，跟他談橋牌、高爾夫球、政治或領帶。毫無例外地，這位大人會因此感到滿意，很高興能認識像我這樣識大體的人。

Chapter 2

　　我過著如此孤獨的生活,沒有一位真正可以談心的人。直到六年前,我的飛機在撒哈拉沙漠故障,引擎的某個零件壞掉了。由於我身邊沒有機師,也沒有乘客,所以我決定獨自挑戰這困難的修繕任務。這對我來說,是件攸關生死的問題,我連八天份的飲用水都沒有。第一天晚上,我在遠離人煙一千英哩的沙地上睡覺,覺得自己比在汪洋大海上,緊巴著木筏,漫無邊際漂流的遇難者還孤單。那天破曉之際,我被一道奇異而纖細的嗓音叫醒,你可知道那時我有多驚訝。那道嗓音說……

　　「請你……為我畫一隻綿羊吧!」
　　「什麼?」
　　「為我畫一隻綿羊!」

我嚇到跳了起來，猶如被雷擊。我揉了揉眼睛，定睛看向噪音的來源。有一位奇特的孩子，正一本正經地端詳著我。這是我事後為他畫的肖像畫中最好看的一張。當然，我的畫作比我真正的模特兒難看許多，但這不是我的錯，我的畫家事業在六歲就被大人潑了一大桶冷水，讓我從此作罷。所以除了那兩張看得見內部與看不見內部的蟒蛇畫作，我不曾再提起畫筆。

　　總之，那時我睜大雙眼，不可思議地看著眼前這位孩子。別忘了，我可是飛機失事，掉落在人跡罕至的沙漠裡。而這孩子看起來一點也不像迷失於荒漠的樣子，他似乎毫不疲憊，也不飢餓乾渴，看起來無所畏懼。他完全不像在人跡罕至的沙漠中走失的小孩。我愣了好一會兒，才開口問他：

「你⋯⋯你在這裡做什麼？」

只見他溫柔而堅定地覆述他的要求，彷彿這是一件重要的事：
「請你⋯⋯為我畫一隻綿羊⋯⋯」

　　人們遇見太詭異、太令人措手不及的事時，總是不敢不服從。而同樣荒謬的是，在遠離人煙一千英哩的地方，在死亡隨侍在側的威脅下，我竟從口袋掏出一張紙和一枝筆。突然，我想起自己學過的地理、歷史、算術和文法。

我有點不高興地告訴那位孩子，我不會畫畫。他回答：「那不礙事，為我畫一隻綿羊吧。」但我從來沒畫過綿羊，因此我為他畫我唯一擅長的其中一張畫——看不見內部的蟒蛇，而他的回應使我完全傻掉。這位小人兒說：「不！不！不！我不要一隻吞噬大象的蟒蛇。蟒蛇很危險，而大象太巨大了，我住的地方一切事物都很渺小。我只要一隻綿羊，請為我畫一隻綿羊。」

　　於是我又為他畫了一隻綿羊。他聚精會神地看了好一會兒，接著說：「不！這隻綿羊早就病得不輕了，畫別隻吧。」

　　我只好再畫一隻。

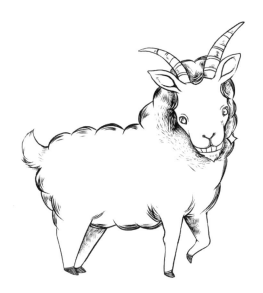

　　只見這位小人兒笑得可愛，以寬容的語氣說：「你自己看看……這不是綿羊，這是隻公山羊吧！牠頭上還有兩支角呢……」

　　我又重新畫一隻。

　　但結果跟剛才一樣，他還是不滿意：「這隻太老了，我要一隻可以活很久的綿羊。」我開始不耐煩，想要快點結束這一切，好去拆解我的引擎。我亂塗一番，創作了這幅畫作。

　　我把畫丟給他：「畫好了！你要的綿羊在這個箱子裡面。」誰知道這位挑剔的小小審判官卻綻放笑顏，驚喜地說：「就是這個！這正是我想要的。你覺得我應不應該給這隻綿羊很多草呢？」

　　「為什麼？」
　　「因為我住的地方很小很小……」
　　「一點點草就夠了，相信我。我給了你一隻很小很小的綿羊。」
　　他把頭湊近那張畫：「沒有你說的那麼小呀……你看！牠睡著了……」

　　就這樣，我認識了小王子。

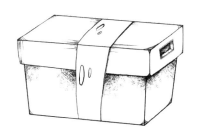

Chapter 3

　　為了知道他來自哪裡，我花費一段相當長的時間打探。

　　這位小王子問了我許多問題，卻從不理會我提出的問題。我只能透過他漫不經心吐出的隻字片語，慢慢拼湊有關於他的一切。一如他第一次看見我的飛機時（我就不畫我的飛機了，你知道的，畫一架飛機對我來說太過複雜），他提出的問題：

「這到底是什麼東西呀？」

「這不是『東西』，它會飛行喔。這是我的飛機。」

我自豪地向他透露我會駕駛飛機，他卻大叫：

「什麼？你是從天上掉下來的！」

「是的。」我不好意思地回答。

「啊！真有趣……」

小王子咯咯地笑，看起來真的很可愛，但他俏皮的笑聲卻無意間激怒了我。我不喜歡別人把我的不幸看作兒戲。接著，他又說：

「你也是從天上來的啊！你來自哪顆行星呢？」

我突然靈機一動，想趁機解開他的身世之謎：
「這麼說來，你來自另一顆行星囉？」

但是他沒有回答我。他只是輕輕地側頭，凝神盯著我的飛機說：
「說的也是，你搭乘這個……不可能來自很遙遠的地方……」

他陷入漫長的沉思，接著從口袋掏出我畫給他的綿羊，看著自己的寶物，再度陷入思緒。

可想而知，我非常在意「另一顆行星」這件事，我半信半疑，想要盡己所能地追問細節。「你從哪裡來，我的小人兒？你的家在哪兒呢？你要把我的綿羊帶到哪裡去？」

他安靜地想了一會兒，回答我：「你給我的箱子有個好處，那就是

晚上可以讓綿羊睡在裡面。」

「當然啦，如果你乖乖的，我還可以給你一條繩子，如此一來，白天你就可以把綿羊綁起來⋯⋯再給你一個樁子吧。」但是我的建議似乎冒犯了小王子。

「綁起來？多麼可笑的念頭啊！」
「假如你不把牠綁起來，牠會到處亂跑，說不定會走失喔！」

我的這位小朋友又忍不住咯咯笑了起來。

「你要牠跑到哪裡去呀！」
「任何地方都有可能啊，牠可能往前走⋯⋯」

只見小王子認真而嚴肅地解釋：「你別擔心，我住的地方非常非常小。」

最後，他又說了一句，聲音似乎有點憂鬱：「牠前方的路並沒有多長，不可能走遠⋯⋯」

Chapter 4

　　於是，我得知了第二個重要線索：小王子的行星可能比一棟房子還小！

　　這一點並沒有令我非常訝異。我很清楚，除了人們為之命名的巨大行星，例如地球、木星、火星、金星，宇宙中還有數不盡的小行星，它們小到連用望遠鏡都很難觀測。當某位天文學家發現其中一顆小行星，他通常會用一組編號來為它命名，例如「3251 號行星」。

　　我有充分的理由，可以確信眼前這位小王子的行星是 B612 號行星。這顆行星只在一九〇九年，被某位土耳其天文學家觀測到一次。

那時，他在國際天文學會上提出一篇冗長的報告，說明他的新發現，但是因為他的土耳其服裝很不入時，所以大家難以相信他。大人就是這個樣子。

幸虧 B612 號行星這件事廣泛流傳，導致土耳其的獨裁者以死刑威脅人民，強迫他的子民穿上歐洲人的服裝。一九二〇年，那位天文學家再次提出報告，這次他穿得高貴而華麗，全世界都相信了他。

我如此不厭其煩地詳細說明 B612 號行星，並且告訴你它的編號，是因為這就是大人的習性，大人都沉迷於數字。若你向他們介紹一位新朋友，他們從來不會問你重要的事。

他們從來不問你：「他的聲音聽起來怎麼樣？喜愛什麼遊戲？他喜歡抓蝴蝶嗎？」他們會

問：「他幾歲？有幾位兄弟？體重多少？他的父親年收入多少？」大人只能透過這些數字，去認識一個人。

假如你告訴大人：「我看見一間用玫瑰色紅磚砌成的房子，窗邊栽種著天竺葵，屋頂上的鴿子三兩成群……」他們無法想像這間房子究竟長怎樣。你應該告訴他們：「我看到一間價值十萬法郎的房子。」如此一來，他們才會大叫：「多美的房子呀！」

同樣道理，假如你告訴他們：「這位小王子存在的證據是……他很可愛，他愛笑，而且想要一隻綿羊。一個人想要一隻綿羊，就證明他真的存在。」他們肯定會聳聳肩，把你當成不懂事的小孩子！但是如果你告訴他們：「他來自 B612 號行星。」他們將被說服，不再質問你各種問題。大人就是這樣，你不應該過度要求他們。小孩子要寬容對待大人。

可是，當然囉，對我們來說……對了解人生的我們來說，數字實在沒有太大的意義！其實，我本來很想以敘述童話故事的方式，為這本書開頭。我本來想這樣開場：

「從前從前，有一位小王子，住在一顆跟他自己差不多大的行星上，而他需要一位朋友……」這樣的敘述對真正了解人生的人來說，更顯真實。

可是我不喜歡別人小看我的書，敘述這些回憶可是讓我傷感不已。我的朋友帶他的綿羊遠去已有六年，我留在此地，試圖描繪他，就是為了不要忘記他。

忘記朋友多麼令人傷心啊！你要知道，並不是所有人都有朋友。如果我忘了小王子，我可能會變得跟大人一樣，除了數字，再也沒有能夠引起我興趣的東西。因此，我買了一盒顏料和幾支鉛筆。在我這個年紀再次提起畫筆，是很不容易的，而且我只在六歲時，畫過看得見內部和看不見內部的蟒蛇，除此之外，我再也沒有繪畫過！但是當然啦，我將盡最大的努力，畫得像樣一點，不過我不敢確定是否會成功，也許這一張畫得還可以，但下一張卻畫得不太像。我的比例尺也可能弄錯，導致小王子有時變得太大，有時又顯得太小。說實話，他的衣服顏色我也猶豫好久呢！於是我不斷嘗試，完成的畫作有好有壞。關於小王子，我很可能搞錯一些重要的細節，但是你應該原諒我，因為我的這位小朋友從來不向我解釋，或許是因為他深信我跟他一樣吧。但很不幸的，我不知道該怎麼從箱子外面，窺探箱子裡面的綿羊……我也許有點像大人了。

我大概老了。

Chapter 5

　　日子一天一天過去，每一天我都多認識小王子一點，他的行星、啟程的原因，以及整個旅途。這些都是他回想的時候，無意間透露出來的。與他認識的第三天，我得知了巴歐巴（非洲盛產的錦葵科植物，巨大無比）戲劇性的故事。

　　這次的發現也得歸功於綿羊，因為小王子突然問我以下的問題。他看起來極為困惑。

　　「這是真的嗎？綿羊會吃灌木嗎？」
　　「是的，這是真的。」
　　「啊！太棒了。」
　　我不明白為什麼綿羊吃灌木這麼重要，而小王子又說：
　　「這麼說來，綿羊也吃巴歐巴嗎？」

我提醒小王子，巴歐巴不是灌木，而是跟教堂一樣大的樹木，即使你找來一群大象，都不會比一棵巴歐巴大。

　　大象的比喻使小王子笑開來：
　　「牠們應該一隻一隻疊起來……」

　　接著，他機靈地說：
　　「巴歐巴一開始也是很小棵的。」

　　「沒錯耶！但是你為什麼要讓綿羊吃巴歐巴？」

　　誰知他竟然哼了一聲：「喔！還用說嗎！」彷彿這根本不需解釋。但為了搞懂這個道理，我苦思良久。

　　事情是這樣的。小王子住的行星和別的行星一樣，有好的草，也有雜草。當然，好的種子會長好草，壞的種子會長雜草，但是種子是看不見的，它們在大地裡睡覺，人們難以探究。直到其中一顆種子被甦醒的渴望所驚擾，伸出頭來，害羞地向太陽打招呼，蹦出一株柔弱的嫩芽。如果這是蘿蔔或玫瑰的嫩芽，我們會讓它自由長大，如果是雜草的嫩芽（在我們能夠辨別的情況下），則會立刻拔掉。

　　然而，小王子的行星有著可怕的種子——巴歐巴的種子，那顆行星

的土壤深受其害，如果遲了一步去拔巴歐巴，便沒有人能夠拔掉它。

巴歐巴將塞滿整個行星，樹根貫穿地殼。假如那顆行星太小，巴歐巴太多，整個行星將會爆裂。

稍後，小王子告訴我：「這是紀律的問題。一個人早上洗完澡，應該小心翼翼地為行星清掃。如果你能夠在玫瑰叢中，辨認出巴歐巴（這兩者還小的時候，長得很相似），你應該刻不容緩地拔掉。這工作很煩人，但很簡單。」

有一天，他勸我畫張漂亮的畫，將這個觀念灌輸給這顆行星上的所有孩子。他告訴我：「假如有一天他們去旅行，這張畫將對他們有所幫助。有時候將工作拖晚一點再做，並不要緊，但是如果你面對的是巴歐巴，這樣做會帶來大災難。我知道有一顆行星上住著一位懶鬼，他曾經忽略三棵巴歐巴，任它們生長……」

於是，我在小王子敘述的同時，畫下那顆行星。我很討厭以假道學的口吻說話，可是巴歐巴的危險性是如此容易被忽視。我一想到那些在太空中迷路，不小心到達那顆行星的人，可能面臨多麼可怕的情景，我就不禁破一次例，大聲疾呼：「孩子們！小心巴歐巴！」

這麼做是為了警告我的所有朋友，他們像我一樣，不知道有一種確實存在的危險早已慢慢靠近，所以我聚精會神地完成這張畫。這則故事給我的教訓，值得我耗費這麼多心力，也許你會問：「為什麼這本書裡，其他畫都不像巴歐巴這麼壯觀？」答案很簡單，我試過畫這麼壯觀的畫，但都沒成功。我可以把巴歐巴畫得如此壯觀，大概是因為情勢緊急，逼迫我表現得異常出色。

Chapter 6

喔，小王子！我已慢慢了解你小小生命的憂傷……曾經有一大段時間，你唯一的娛樂是欣賞日落，享受那寧靜的歡愉。我是在認識你的第四天早上，發現這件有關於你的小事。當時，你告訴我：

「我很喜歡日落，走吧，我們去看日落……」

「可是我們得等等……」

「等什麼？」

「等太陽下山呀。」

起先你很驚訝，而後你自己笑了起來，告訴我：

「我總以為自己還待在家裡！」

大家都知道，美國正中午的時候，法國的夕陽正在西下。只要能在一分鐘之內，從美國趕到法國，你就可以欣賞日落，不幸的是，法國太

遠了，這只是個假想。

　可是在那顆小行星上，你只需挪動椅子幾步。只要你願意，你隨時可以欣賞落日餘暉。

　「有一天，我總共看了四十三次日落！」你對我說。
　而後，你又補了一句：
　「你知道……一個憂鬱的人總是喜歡日落。」
　「所以看四十三次日落的那天，你很憂鬱嗎？」

　小王子沒有回答我。

Chapter 7

　　第五天，再次歸功於綿羊，我又揭開一個小王子的生活秘密。他突然提出問題，完全沒有開場白，彷彿這問題是他思索已久的嚴肅課題：

　　「既然綿羊會吃灌木，那麼牠會吃花嗎？」

　　「綿羊會吃牠眼前的所有東西。」

　　「即使是有芒刺的花？」

　　「是的，即使是有芒刺的花。」

　　「既然如此，芒刺有什麼用呢？」

　　誰知道？那時，我正忙於拔掉引擎上，一根鎖得太緊的螺絲。我很著急，因為我發現飛機故障的情形超乎想像地嚴重，而我的飲用水一天天減少，我擔心情況會變得更糟。

「那些芒刺有什麼用呢？」

小王子一旦問了問題，往往會追問不捨，而我已被那根螺絲激怒，於是隨口回答：

「芒刺一點用也沒有，純粹是花的惡作劇啦！」
「喔！是這樣啊！」

小王子安靜下來，但過沒多久，他便忿忿不平地推翻我：
「我不相信！花是軟弱的，她們很無辜，用盡全力在保護自己，全心全意相信她們的芒刺是威力無邊的武器……」

我完全沒回應他，因為我正在自言自語：
「假如這根螺絲再這麼頑固，我就要用鐵鎚一舉轟掉它。」
誰知道小王子竟然又來擾亂我的思緒：
「你真的相信，那些花……」

「不相信！我不相信！我什麼也不相信啦！我只是隨口回答罷了，我沒空，我正在忙很嚴肅的事情！」

他傻傻望著我。

「嚴肅的事情？」

他看我手裡拿著鐵鎚，手指被潤滑油染黑，俯在一個他覺得很難看的東西上方。

「你說話真像那些大人！」

他這麼說令我有點慚愧，但是他還是殘忍地繼續說：「你把一切弄得混亂……你把一切都弄得亂七八糟！」

他被我徹底激怒，頻頻搖頭，使那頭金髮在風中狂亂甩盪。

「我認識住在某顆行星的紅臉先生。他從沒聞過一朵花；從沒注視過一顆星星；從沒愛過人。他除了計算加法，什麼也沒做過。他整天像你一樣，一遍又一遍地說『我很嚴肅，我很嚴肅！』還引以為傲。但他這樣，不算是人，只是個蘑菇！」

「什麼？」

「蘑菇！」

小王子氣得臉色發白。他又說：「幾百萬年來，花都在製造芒刺；幾百萬年來，綿羊都在吃花，但是去探問為什麼花要辛辛苦苦製造沒用的芒刺，卻不是一件嚴肅的事？綿羊和花之間延續幾百萬年的戰爭不重要嗎？這比那位紅臉先生的加法更嚴肅、更重要吧？假如我認識一朵全世界獨一無二的花，她只存在於我的行星，別的地方都無法找到她的蹤影，而一隻小綿羊卻在某天早晨，一口吃掉她，而且還不曉得自己到底做了什麼好事，這不重要嗎？」

　　小王子氣得臉紅脖子粗：「假如有一個人愛上一朵花——一朵在萬千行星當中，獨一無二的花，那麼光是仰望星空，即足以讓他感到幸福。當他仰望星空，他可以對自己說『我的花，就在某一顆星星上⋯⋯』而如果綿羊一口吃掉那朵花，他便瞬間失去整片星空，猶如滿天繁星都隕落⋯⋯而你竟然認為這不重要！」

　　他再也說不下去，禁不住地啜泣。夜幕低垂，鐵鎚從我的手裡滑落，咚一聲掉到地上。我再也不在意我的鐵鎚、螺絲，乾渴與死亡的陰霾。在一顆行星上，在我們的行星——地球上，有位小王子需要安慰！我把他抱進懷裡，輕聲安慰，我對他說：「你所愛的那朵花不會有危險⋯⋯我幫你的綿羊畫個嘴套⋯⋯我為你的花畫張護身符⋯⋯我⋯⋯我⋯⋯」我不曉得該說什麼，覺得自己很笨拙。我不曉得如何靠近哭泣的小王子，再次追上他，牽他的手繼續走下去⋯⋯唉，眼淚的世界是非常神秘的。

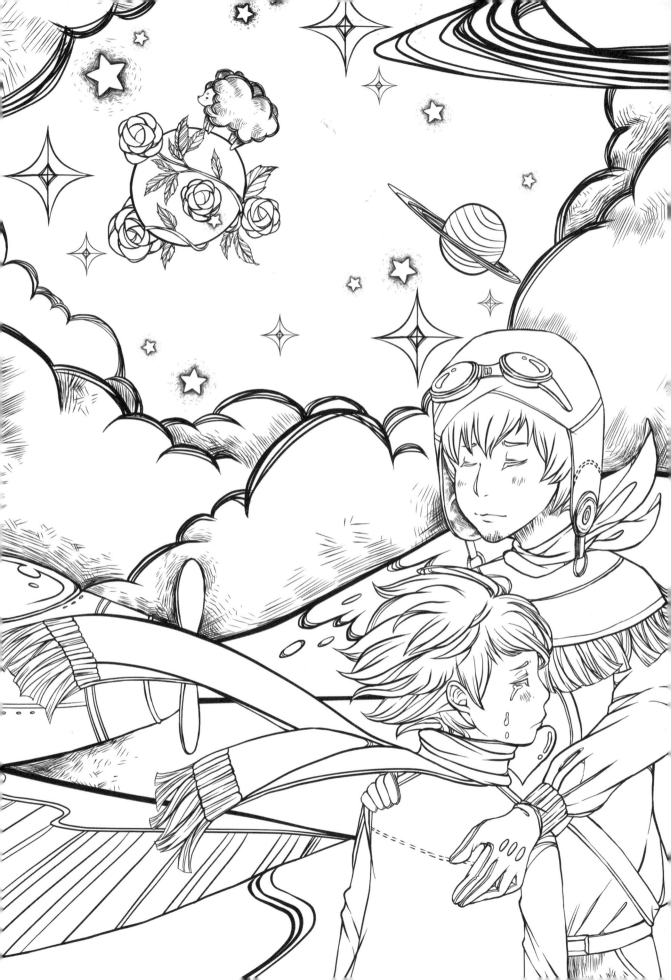

Chapter 8

　　我很快就對這朵花有進一步的認識。在小王子的行星，大部分的花都很簡單，只有一圈花瓣，不佔空間，絕對不會打擾別人。她們早上現身於草叢，晚上即凋謝。可是有一天，風吹來一顆不知來自何處的種子，長出一朵不可思議的花。小王子仔細觀察這株與眾不同的嫩芽，懷疑可能是新品種的巴歐巴。可是這棵小灌木很快就停止生長，準備開花。小王子親眼目睹這粒巨型花苞的誕生，直覺告訴他，將有奇蹟發生，可是那朵花只顧著在綠色溫床的保護下，無盡地裝扮自己。她精心挑選顏色，從容不迫地著裝，一瓣一瓣地整理花瓣。她不願意自己開出來的花瓣跟罌粟花一樣皺，全心全意地準備驚艷登場。喔！是的，她超級愛美！

　　她神祕的沐浴持續了一段時日，終於在某天早上，日出之際，正式登場。

但裝扮那麼久的她，卻打著呵欠說：「啊！我剛醒來……請見諒……我還沒梳裝打扮……」

儘管如此，小王子還是禁不住地讚美：「妳好美啊！」

「可不是嗎？」那朵花溫柔地接話：「我誕生於日出之時……」

小王子早就料到她不會太謙虛，但她真的明豔動人！

不久後，她又說：「我想現在該吃早餐了，你是否應該為我著想一下……」

小王子頓時尷尬不已，他趕緊提來一桶清水，為嬌花服務。

此後，那朵花用她多餘的虛榮心，不斷折騰著小王子。舉例來說，有一天她談到自己的四根芒刺：

「牠們會來吧……有利爪的老虎！」

小王子否定這想法：「我的行星沒有老虎，何況老虎不吃草。」

「我不是草。」那朵花溫柔地回答。

「喔！請原諒我……」

「其實我不怕老虎，但是我怕風。你沒有屏風嗎？」

「怕風？……這就糟了！」小王子心想，這朵花原來是個相當複雜的生物。

「當夜晚降臨，我希望你把我放進玻璃罩，你住的地方好冷，我的家鄉可是……」

她猛然住口，因為她來的時候還是一顆種子，沒見識過別的行星，再說下去這個拙劣的謊言就會露餡，為了掩飾自己的困窘，她咳了兩三聲，把錯怪到小王子頭上：

「我的屏風呢？」

「我正要去找，但妳一直在數落我！」

她又乾咳幾聲，當作對小王子的譴責。

於是，即使是一片好意愛護玫瑰的小王子，也開始質疑她，因為之前小王子把那些無關緊要的話看得太認真，而變得悶悶不樂。

有一天，他對我說：「我不應該理會她的話，我們不應該理會花說的話。我們應該只欣賞她們，只聞她們的芳香。那朵花使我的行星滿溢香氣，但我卻無法享受，或許我被老虎的故事嚇到了吧，我本來應該抱有同情心的……」

他又坦白地告訴我：「其實是我不懂得去了解他人！我應該根據她的行為去評斷她，而不是根據她的話語。她為我帶來芬芳，照亮我的生活，我不應該逃離她的身邊……我應該想到，她那可憐詭計所蘊藏的溫柔。花是這麼的矛盾！但我當時太年輕了，我不懂得愛她……」

Chapter 9

我相信他的逃亡是得到一群野生候鳥的幫助。出發的那天早上，他把他的行星整理得有條不紊，謹慎地打掃他的活火山。他擁有兩座方便的活火山，可以在上面加熱早餐。他還擁有一座死火山，但一如他所說的：「誰料得到？」所以他也細心打掃那座死火山。你要知道，只要好好打掃，火山便會輕輕地、有規律地燃燒，而不致爆發。火山爆發的灰，和煙囪冒出來的東西是一樣的。顯然，在我們的地球上，人類實在是太渺小，無法打掃地球的火山，所以火山才會為我們帶來一大堆麻煩。

那天，小王子帶點憂鬱地拔掉最後幾株巴歐巴幼苗，他相信自己不會再回去，這些他所熟悉的日常工作突然變得特別親切。當他最後一次為那朵花澆水，準備把她罩進玻璃罩時，他禁不住落下淚滴。

「再見！」他對花說。

但是花沒有回應他。

「再見！」他又說了一次。

那朵花咳嗽咳了一陣子，但不是因為她著涼了。終於，她開口對小王子說：「我以前太傻了，請你原諒我，開心點吧！」

小王子很驚訝，花竟然沒有責備他。他愣愣地站著，手拿玻璃罩，不知如何是好。他無法理解這份平靜的溫柔。

花對他說：「沒錯，我愛你，只是你不曉得，那是我的錯。但沒有關係，你和我一樣傻。開心點吧……把玻璃罩拿開，我已不再需要它。」

「可是，風怎麼辦……」

「我沒那麼容易受寒……涼爽的晚風對我很好，我可是一朵花呢。」

「如果有動物來……」

「假如我要跟蝴蝶交朋友，我得養兩三隻漂亮的毛毛蟲，不然誰來拜訪我呢？你……你將遠遠地離開我，至於那些體積大一點的動物，我一點也不怕，我有我的芒刺。」

她天真地展示身上的四根芒刺，又說：
「你不要扭扭捏捏，很討厭耶，要走就走吧！」

她不願意小王子看到自己落淚。她可是一朵非常驕傲的花呢……

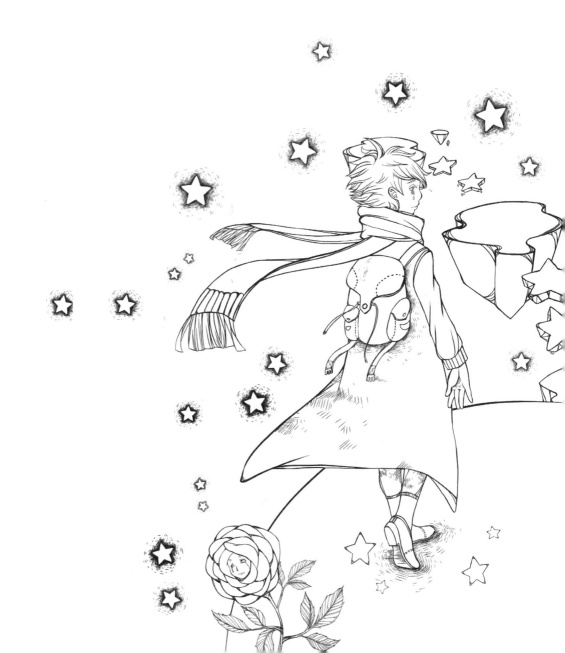

Chapter 10

　　小王子來到 325 號、326 號、327 號、328 號、329 號和 330 號行星的附近。他一路拜訪他們，想要一邊找工作，一邊增廣見聞。

　　第一顆行星住了一位國王，他身穿裝飾有黃鼠狼毛皮的絳紅色大禮袍，端坐在一張造型簡約，卻威風凜凜的寶座上。

　　「啊！來了一位部下。」國王看見小王子，叫了出來。
　　小王子自言自語：「他怎麼認識我？我們從來沒見過面呀！」
　　小王子不曉得國王把世界簡化了，所有人都是他的部下。
　　「走近一點，我要看清楚你的臉。」國王說。

　　這位國王以自己的國王身分為榮。

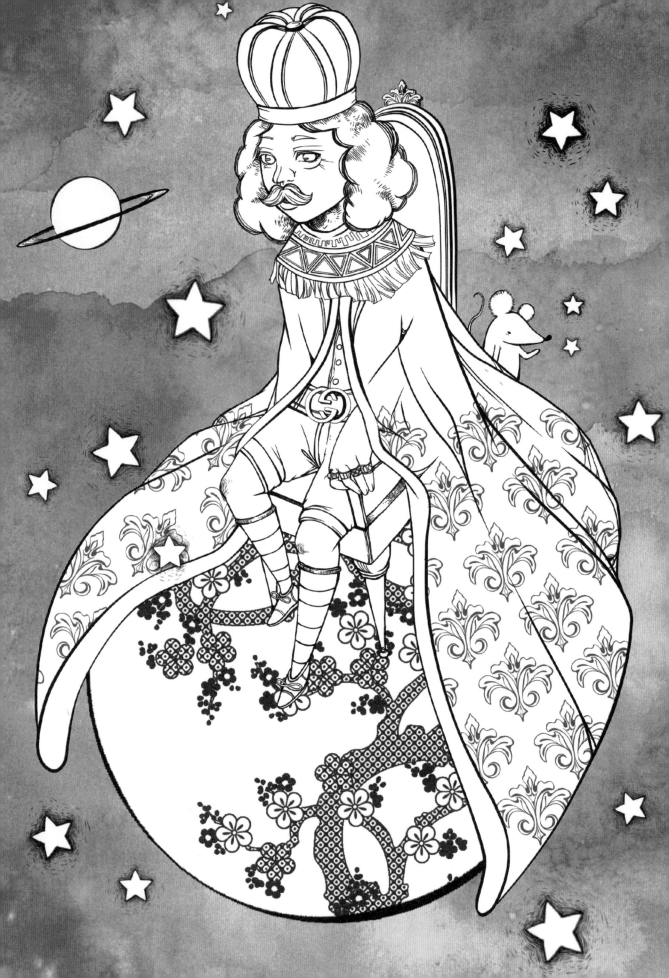

小王子努力搜尋可以坐下來的地方，可是整顆行星已被國王華麗的黃鼠狼毛皮禮袍佔滿。他只能站著，但他非常疲倦，忍不住打起呵欠。

　　國王說：「在國王面前打呵欠是不禮貌的，我禁止你這樣做。」
　　「我沒辦法控制。」小王子困擾地說：「我歷經了漫漫旅途，都沒睡覺……」
　　國王又說：「好吧，我命令你打呵欠，我好幾年沒看別人打呵欠了，打呵欠對我來說很新奇。來吧！再打一個呵欠，這是國王的命令。」
　　「你這樣讓我很為難……我打不出來了……」小王子臉紅地說。
　　「哼！哼！」國王回應：「那麼，我……我命令你一下子打呵欠，一下子……」

　　國王一陣口吃，略顯狼狽。

　　國王最在意的是，他的權威是否受人尊敬，他受不了別人違背他的命令。他是位專制君主，個性卻很好，只下達合理的命令。他常說：「我若命令一位將軍變成海鳥，而那位將軍不服從，這不是他的錯，是我的錯。」

　　「我可以坐下嗎？」小王子羞怯地問。
　　「好，我命令你坐下。」國王回答，威風地拉一拉黃鼠狼毛皮禮袍，讓出空位。

小王子覺得很奇怪，行星這麼小，國王能統治什麼呢？

他說：「陛下……請容許我問你一個問題。」
「好，我命令你問我問題。」國王急忙地說。
「陛下……你統治什麼呢？」
「一切。」國王的回答簡潔有力。
「一切？」

國王慎重地指向他的行星、其他行星，以及天上繁星。

「這一切？」小王子問。
「沒錯，這一切……」國王回答。
他不只是專制君主，也是全宇宙的君主。
「那些星星服從你嗎？」
「當然囉！」國王回答：「他們不敢怠慢我，我無法容忍造反。」

這麼大的權力使小王子訝異。假如他擁有這麼大的權力，他不必挪動椅子，就可以在一天內看超過四十三次、七十二次，甚至一百次、兩百次的日落……小王子想起他所離棄的行星，突然有點感傷，於是他果敢地向國王懇求一個恩惠。

他說：「我好想看日落……請讓我如願以償……命令太陽下山吧……」

「我若命令一位將軍，像蝴蝶一樣翩翩飛舞，穿梭於花叢，或是寫一齣悲劇、變成一隻海鳥，而那位將軍不執行命令，這是誰的錯呢？是他還是我？」

「這是你的錯。」小王子肯定。

「對！」國王回答：「權力奠基於道理，我們對他人的要求理當在他人的能力範圍之內。假如你命令人民去跳海，他們便會造反。我有權要求別人服從，是因為我的命令很合理。」

「那麼我的日落呢？」小王子猛然想起自己的要求，他總是追問不捨。

「你將會得到你的日落，我會為你達成這件事。但是，依據我統治國家的權術，我將等到條件對我有利的時候下達命令。」

「那是什麼時候呢？」小王子問。

「哼！哼！」國王輕哼，翻查一本厚重的日曆。「哼！哼！將在……接近……接近……將在今天晚上，接近七點四十分的時候！那時你將看到日落乖乖服從我的命令。」

小王子打了呵欠，很遺憾自己失去一次看日落的機會。不久後，他開始不耐煩。

他對國王說：「我在這裡無事可做，我要走了。」

「不要走！」國王說。

國王很驕傲自己能擁有一位部下：「不要走，我任命你當部長！」

「哪種部長？」

「部長……司法部長！」

「但是沒有人可以審判呀！」

國王說：「誰曉得，我還沒巡視過國土呢！我太老了，而且沒有空間擺放華麗的四輪馬車，至於步行……會讓我太疲倦。」

「喔！但是我巡視過了！」小王子說，側身看向行星的另一端。「那邊沒半個人……」

國王回答：「既然如此，你自己審判自己吧！這是最困難的，審判自己比審判別人困難好幾倍。假如你能好好地審判自己，你便是真正有才智的人。」

小王子說：「我嗎？我可以在任何地方審判我自己，不需要住在這裡。」

「哼！哼！」國王說：「我相信我的行星躲著一隻老鼠，我曾在夜間聽過牠的聲音。你可以審判這隻老鼠，隨時判牠死刑，牠的生命取決於你的審判。但是為了節省資源，你每一次都得赦免牠，因為我們只有

一隻老鼠。」

　　「我……」小王子回答：「我不喜歡死刑，而且我想離開這裡。」

　　「不！」國王吶喊。

　　小王子已準備好行囊，但他不願再傷老國王的心，他說：

　　「假如陛下希望我服從，陛下可以給我一個合理的命令，例如，命令我在一分鐘之內離開。我覺得這命令的所有條件，似乎都有利於國王……」

　　國王沒有回應，小王子猶豫了一會兒，嘆口氣，轉身離開。

　　「我任命你做我的大使。」國王急忙地大喊，又擺出威風凜凜的樣子。

　　「大人都很奇怪。」離開的途中，小王子不斷對自己這麼說。

Chapter 11

第二顆行星住了一位愛慕虛榮者。

「啊！啊！有位崇拜者來訪！」那位愛慕虛榮者遠遠看到小王子，放聲大喊。對於愛慕虛榮者來說，所有人都崇拜他。

小王子說：「你好，你知道你的帽子很可笑嗎？」

「這是用來還禮的。」愛慕虛榮者回答。「如果有人為我喝采，我便用這頂帽子還禮，可惜從來沒人經過這兒。」

「啊！是嗎？」小王子疑惑地說。

「不然請你鼓掌一下。」愛慕虛榮者說。

小王子開始鼓掌，愛慕虛榮者掀起他的帽子，優雅地還禮。

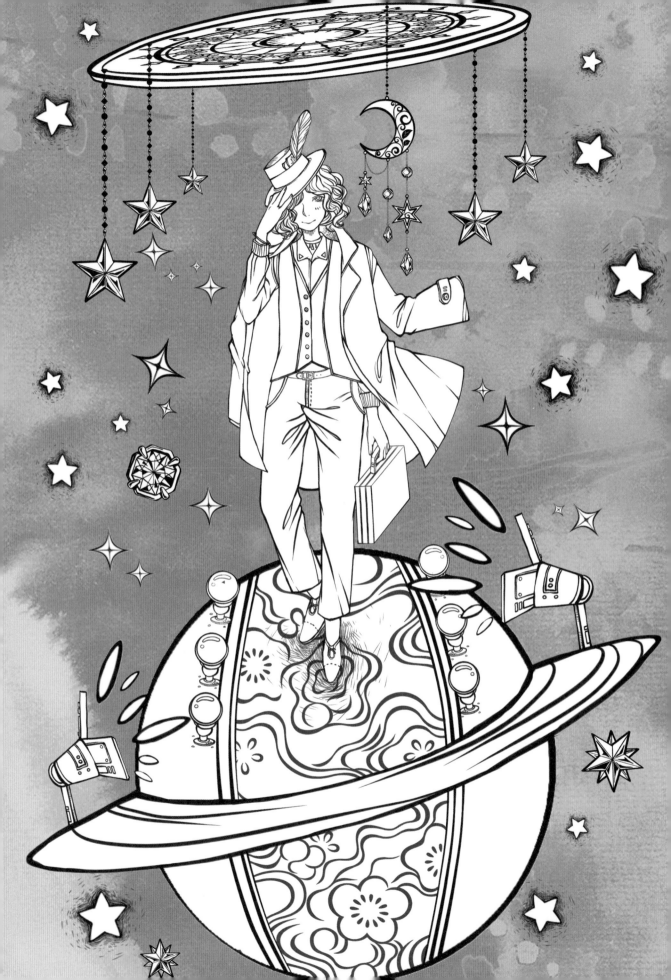

「這比拜訪國王好玩呢！」小王子自言自語，繼續鼓掌。愛慕虛榮者也再次掀動帽子，予以還禮。

　　這遊戲玩了五分鐘，小王子漸漸感到乏味。他問：

　　「要怎麼做你才不會把帽子戴回去呢？」

　　可是愛慕虛榮者沒聽到。愛慕虛榮者永遠只聽得見讚美。

　　「你真的那麼崇拜我嗎？」他問小王子。

　　「崇拜是什麼意思？」

　　「崇拜就是承認我是這個行星上最漂亮、穿著最講究、最有錢、最有智慧的人。」

　　「但是你的行星上，只有你一個人呀！」

　　「不要掃我的興，繼續崇拜我吧！」

　　「我崇拜你。」小王子聳聳肩：「但這有什麼好讓你著迷的？」

　　小王子掉頭就走。

　　「大人真的很奇怪。」他自言自語，繼續上路。

Chapter 12

下一顆行星住著一位酒鬼。這次的拜訪很短暫,卻使小王子極為憂鬱。

他看見酒鬼安靜地坐在一堆酒瓶和空瓶前。「你在做什麼?」他問酒鬼。

「我在喝酒。」酒鬼一臉憂愁地回答。

「你為什麼要喝酒?」小王子問。

「為了遺忘。」酒鬼回答。

「遺忘什麼?」小王子追問,覺得他很可憐。

「遺忘我的可恥。」酒鬼坦白說,垂下了頭。

「怎麼可恥?」小王子問,一心想救他。

「喝酒很可恥!」酒鬼說完便一言不發,猶如掉進死寂的深淵。

小王子不知所措地離開。

離開的途中，他不斷自言自語：「大人實在非常、非常奇怪。」

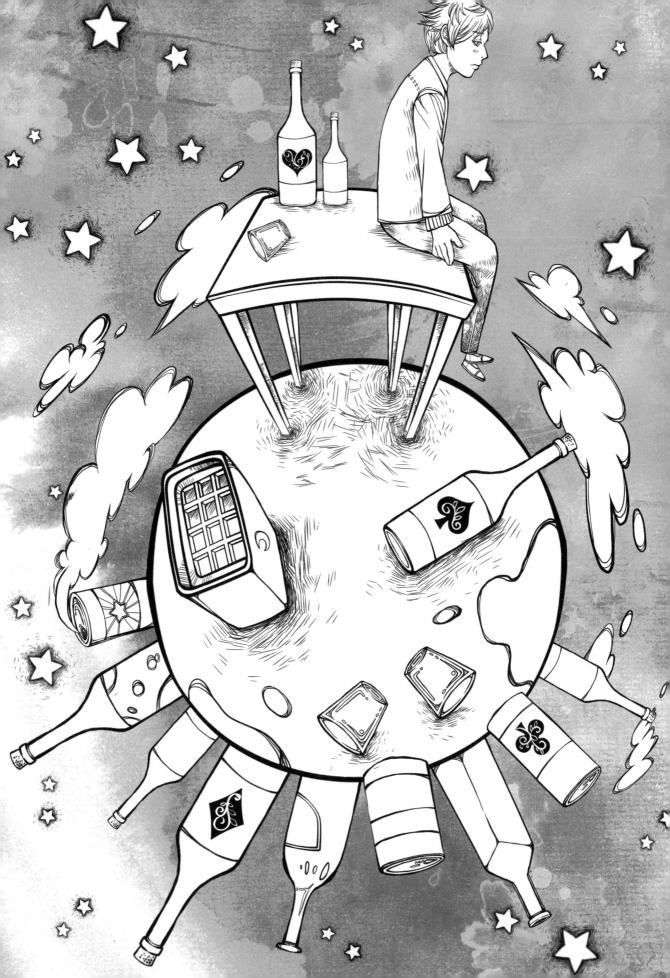

Chapter 13

　　第四顆行星是實業家的行星。這位先生非常忙碌，以致於小王子到達的時候，他連頭也不肯抬起來看一眼。

　　「你好！」小王子對他說：「你的香菸熄了。」

　　「三加二是五，五加七是十二，十二加三是十五。你好。十五加七是二十二。二十二加六是二十八。我沒時間點菸。二十六加五是三十一。喔！一共是五億零一百六十二萬兩千七百三十一。」

　　「什麼東西有五億？」

　　「啊？你還在啊？五億零一百萬的⋯⋯我不能停止計算⋯⋯我的工作實在太多了！我在認真處理很重要的事，不會浪費時間在無聊的問題上！呃，二加五等於七⋯⋯」

　　「五億零一百萬個什麼？」小王子再問一次。在小王子的一生中，你別想他放棄追問。

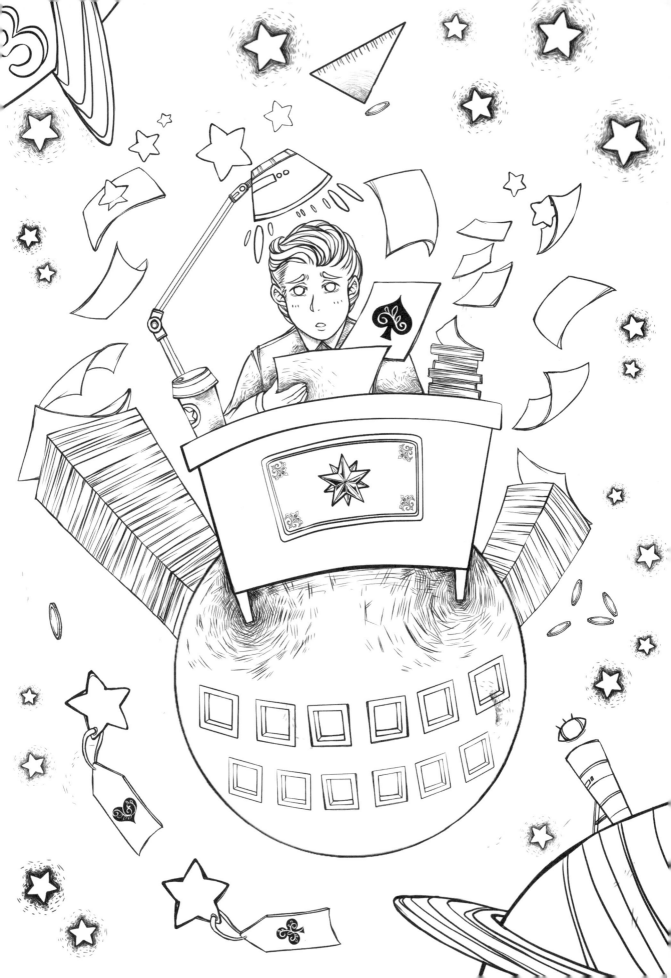

實業家終於抬起頭回答：

「我住在這個行星的五十四年來，只被打擾過三次。第一次是二十三年前，我被一隻不知道從哪裡掉下來的金龜子干擾。牠嗡嗡嗡的聲響，使我算錯某個加法算式的四個項。第二次是十二年前，我為關節炎所苦。我缺少運動，根本沒時間散步。我可是很認真的。而第三次就是現在。我剛才說五億零一百萬……」

「一百萬個什麼？」

這位實業家發現他若不回答小王子，就不可能重獲安寧，於是他說：

「一百萬個小東西，那些有時會出現在天上的小東西。」

「蒼蠅？」

「不對，那些小小的、亮晶晶的東西！」

「蜜蜂？」

「不對。是那些鍍金的小東西，常使懶惰鬼做夢的那個。可是我很認真，我沒時間做夢！」

「啊！是星星嗎？」

「你猜中了，就是星星。」

「你算五億零一百萬個星星做什麼？」

「五億零一百六十二萬兩千七百三十一。我很認真。我，一點也不馬虎。」

「你算這些做什麼？」

「沒什麼，我佔有它們。」

「你佔有星星？」

「是的。」

「但是我之前遇到一位國王，他……」

「國王不佔有，他們只是統治。這不一樣。」

「你佔有那些星星又有什麼用？」

「讓我變成富翁呀！」

「變成富翁對你有什麼用？」

「買別的星星呀，假如有人找得到其他星星……」

「喔……」

這個傢伙的理論有點像酒鬼，小王子心想。

小王子繼續問：

「人要怎麼佔有星星？」

「那些星星是屬於誰的？」實業家急躁地反問。

「我不知道，它們不屬於任何人吧。」

「那麼，它們就屬於我，因為我最先想到這個概念。」

「這樣就可以佔有星星嗎？」

「當然啦,如果你找到一顆鑽石,它不屬於任何人,它就是你的;如果你發現一座不屬於任何人的島,它就是你的;如果你最先發想某個創意,去申請專利,它就是你的。而我佔有星星,因為在我以前,沒有人想過要佔有它們。」

「這倒是真的。」小王子說:「你要星星做什麼呢?」

「我管理它們。我計算它們,一遍又一遍。」實業家回答:「這可不簡單,但我是很認真的!」

小王子仍然不滿意,他說:

「假如我佔有一條圍巾,我可以圍在脖子上,帶去天涯海角;假如我佔有一朵花,我可以任意攀折,帶去天涯海角。但是你不能摘下你的星星呀!」

「可是,我可以把它們放在銀行裡。」

「這是什麼意思?」

「意思是說,我可以將我的星星數目寫在一張小紙條上,再把這張紙條放在抽屜裡。」

「就這樣?」

「這樣就夠了!」

這個好玩,小王子心想。這麼做很有詩意,但這件事不能算重要。

每每提到「重要」，小王子的見解都會迥異於大人。

小王子又說：「我有一朵花，我每天為她澆水；我擁有三座活火山，每個禮拜我都悉心為它們打掃，我也會打掃另一座死火山，誰知道它會不會再次爆發呢？我這麼做，對我的活火山有幫助，對我的花也有幫助，但是你對那些星星，並沒有任何幫助……」

實業家張大了嘴，啞口無言。

不久，小王子便離開。

「大人真的非常奇怪。」一路上，他不斷對自己說。

Chapter 14

　　第五顆行星很奇特，是所有行星當中最小的一顆。那裡的空間剛好夠容納一盞街燈與一位點燈人。小王子不理解在這個宇宙的角落，在這顆既沒房子也沒住戶的行星上，一盞街燈和一位點燈人會有什麼用處。雖然如此，他還是對自己說：

　　「這個人或許有點荒謬，但他絕對不會比之前的國王、愛慕虛榮者、實業家與酒鬼荒謬，至少他的工作有意義。他點亮街燈，彷彿賦予一顆星星或一朵花生命，使它們活過來；他熄滅街燈，便使那朵花或星星入睡。這是個優雅、美好的工作。這才是有用的，因為這工作很美好。」

　　小王子登陸那顆行星，恭敬地向點燈人致敬，他說：
　　「早安！為什麼你剛剛熄滅了街燈？」

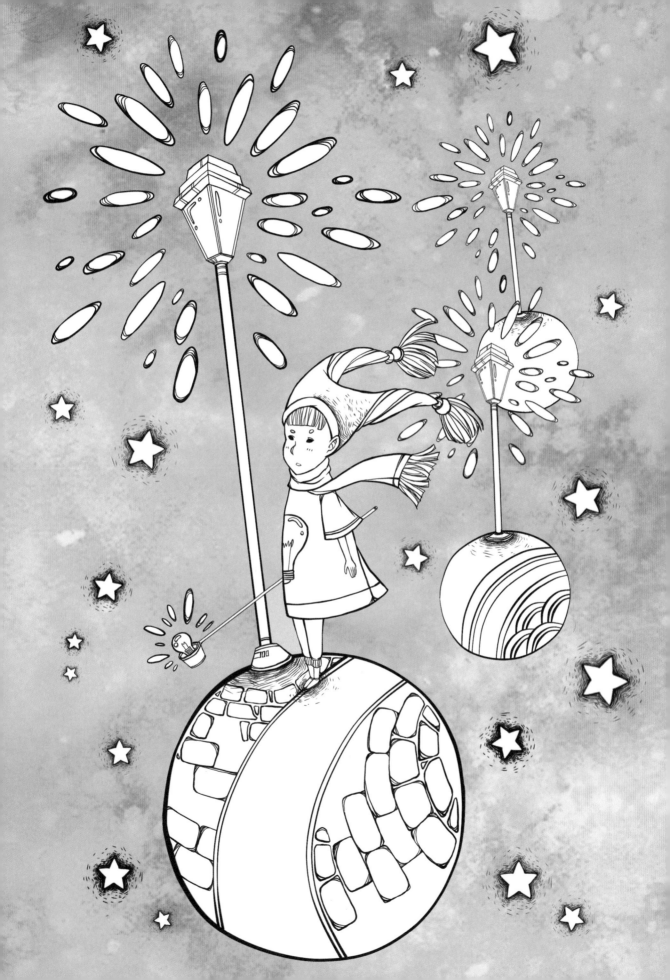

「這是命令。」點燈人回答:「早安!」

「命令是什麼?」

「命令就是『要我熄滅街燈』。晚安!」

接著,他馬上再次點亮街燈。

「為什麼你又點亮了呢?」

「這是命令。」點燈人回答。

「我不明白。」小王子說。

點燈人說:「沒什麼需要你明白的事,命令就是命令。早安!」

他又熄滅了燈。

「這份工作很繁重,以前還算合理,我早上點燈,晚上熄燈,白天的其他時間我可以休息,晚上的其他時間我可以睡覺⋯⋯」

「所以這些年來命令改了?」

「命令沒有改。」點燈人說:「癥結就在這!行星轉得一年比一年快,但命令沒有改!」

「所以呢⋯⋯」小王子說。

「現在行星一分鐘轉一圈,搞得我連一秒鐘的休息時間都沒有。我每分鐘都在點燈、熄燈!」

「好有趣!你的一天只有一分鐘!」

「一點也不有趣！」點燈人說：「我們已經談話一個月了。」

「一個月？」

「是的，三十分鐘，三十天，早安！」

他再次點亮他的街燈。

小王子越看越喜歡他，因為他對自己的工作非常忠誠。小王子憶起，自己挪動椅子追尋日落的往日時光。小王子很願意幫助這位朋友，他說：

「你知道……我有一個方法可以讓你想休息就休息……」

「我需要常常休息。」點燈人說：「但是人啊，不可能既盡責又偷懶。」

小王子接著說：「你的行星這麼小，只要跨三步就可以繞一圈，所以你只要慢慢地走，就可以一直走在太陽底下。你想休息的時候，就去散步吧，如此一來，白天會依照你的期望，要多長有多長。」

「這對我沒有多大用處。」點燈人說：「因為我一生最熱衷的是睡覺。」

「你真是不幸。」小王子說。

「我真是不幸。」點燈人說：「早安！」

點燈人再次熄滅街燈。

小王子繼續上路，他想這個人可能會被其他人輕視，被國王、酒鬼與實業家輕視，但他是唯一不那麼可笑的人，大概是因為他的作為並不是為了自己，而是為了他人著想。

　　小王子惋惜地嘆氣，又對自己說：「這個人是唯一值得結交的朋友，但是他的行星太小，沒空間容納兩個人。」

　　小王子不願承認的是，他捨不得離開這顆二十四小時有一千四百四十四次日落的行星！

Chapter 15

第六顆行星是剛才那顆行星的十倍大，住著一位老先生，他不斷編寫厚重的書籍。

「嗨！來了一位探險家呢！」他看見小王子，大聲呼叫。

小王子在桌子前坐下，喘了一會兒氣，因為他歷經了漫漫旅程。

「你從哪裡來？」老先生問。

「這本厚重的書是什麼？你在這裡做什麼？」小王子問。

「我是地理學家。」老先生回答。

「地理學家是什麼？」

「地理學家是知道哪裡有海、河流、城市、山脈和沙漠的學者。」

「這倒有趣。」小王子說：「總算讓我遇到一份真正的職業！」

小王子用眼睛掃視一遍地理學家的行星，他沒看過這麼壯麗的行星。

　　「你的行星好漂亮，這裡有海洋嗎？」

　　「我怎麼曉得。」地理學家說。

　　「咦？」小王子覺得自己被騙了。「有山脈嗎？」

　　「我怎麼知道。」地理學家說。

　　「城市呢？河流呢？有沙漠嗎？」

　　「這我不得而知。」地理學家回答。

　　「你不是地理學家嗎？」

　　「沒錯。」地理學家說：「但我不是探險家呀！我迫切地需要探險家。地理學家的工作不是去探測城市、河流、山脈、海灣、海洋和沙漠。地理學家非常重要，不能四處閒晃。他離不開工作室，但會在工作室接見探險家。他會詢問探險家，摘記探險家的回憶。假如他覺得某位探險家的回憶很有趣，他會先調查那位探險家的品行。」

　　「為什麼？」

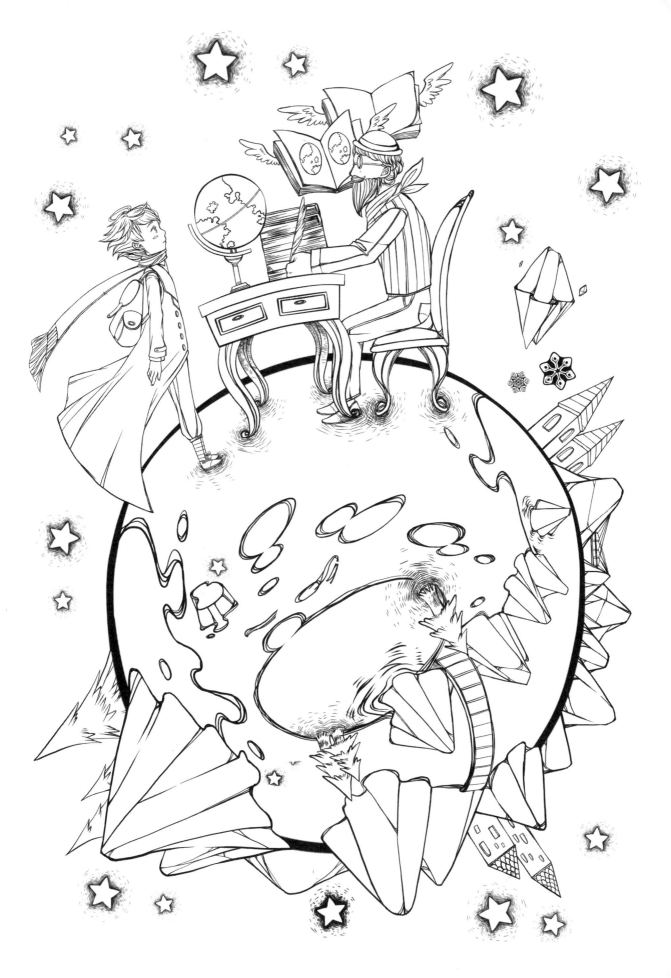

「因為如果探險家說謊，他將為這本地理書帶來麻煩，酗酒的探險家也是。」

「為什麼會這樣呢？」小王子問。

「因為喝醉的人常把一個東西看成兩個。如此一來，一座山可能會被地理學家記載成兩座山。」

小王子說：「我認識一個人，他可能就是最糟糕的探險家。」

「可能吧，而地理學家確認探險家的品行沒問題，才會去詢問探險家的發現。」

「走去看嗎？」

「不，這樣太麻煩了。我們要求探險家提出證據，舉例來說，假如他發現一座高山，我們會要求他帶回一些大石頭。」

地理學家突然興奮地說：

「你……來自遠方吧？你八成是個探險家，請為我描述你的行星。」

地理學家逕自翻開他的筆記本，削起鉛筆。他會將探險家的描述先用鉛筆記下來，等探險家提出證據，再用鋼筆書寫。

「怎麼樣？」地理學家問。

「喔！我住的地方不太有趣，」小王子說：「它很小很小，有三座火山。兩座活火山，一座死火山。可是誰曉得它會不會再次爆發？」

「對啊，誰曉得？」地理學家說。

「我還有一朵花。」

「我們不記載花。」地理學家說。

「為什麼不記載?花是最美的!」

「因為花朝生暮死。」

「什麼叫作『朝生暮死』?」

　　地理學家說:「地理書是最珍貴的書,絕對不會過時。山不太會變更位置,海洋也不太可能乾涸。我們只記載這些永恆不變的事物。」

　　「可是火山死了可以再復活啊。」小王子忿忿不平地說:「什麼叫作『朝生暮死』?」

　　地理學家說:「不管火山是死是活,對我們來說都一樣。我們關心的是山,山是不會變的。」

　　「那什麼叫作『朝生暮死』嘛?」小王子再問一次。

　　在小王子的一生中,你別想他放棄追問他所提出的問題。

　　「意思是『隨時有消失的危險』。」

　　「我的花隨時有消失的危險嗎?」

　　「當然啦!」

　　「我的花是朝生暮死的。」小王子自言自語:「她只能以四支芒刺來抵抗這個世界,我卻把她孤孤單單地留在家裡,一走了之!」

小王子第一次感到懊悔，但他隨即重振精神。

「你建議我接下來去哪裡拜訪呢？」小王子問。
「地球。」地理學家說：「它名聲很好……」

於是小王子走了，一路上都惦記著他的花。

Chapter 16

第七顆行星是地球。

地球不是一顆隨隨便便的行星。嚴格算來,地球上有一百一十位國王(當然啦,不要忘記還有黑人國王)、七千位地理學家、九十萬位實業家、七百五十萬個酒鬼、三億一千一百萬個愛慕虛榮者,也就是說,地球上有幾近二十億個大人。

要說地球有多大嘛⋯⋯在人類使用電力以前,全球六大洲總共有四十六萬兩千五百一十一位點燈人大軍。

從遠一點的地方看過去,這個畫面相當壯觀。這支軍隊的動作有如歌劇院的芭蕾舞團,井然有序。首先,紐西蘭和澳洲的點燈人上台,他們點亮街燈,才去睡覺;接下來,換中國和西伯利亞的點燈人載歌載舞

地上台，再摸索著回到後台；然後輪到蘇俄和印度的點燈人、非洲和歐洲的點燈人、南美洲的點燈人；最後換北美洲的點燈人上台。他們的前後次序從不錯亂，這是場盛大的演出。

只有北極那位唯一的點燈人，以及他的同胞──南極的點燈人，過著悠哉悠哉的生活，一年只工作兩次。

Chapter 17

一個人想危言聳聽，往往必須說一些不實的話。剛才我告訴你的，關於點燈人的事，並不是一段誠實的敘述，可能會讓不認識地球的人抱有錯誤觀念。人類所佔的地球表面積其實很小，假如生活在地球的二十億人口全部站在一塊兒，大家靠得很緊，像在參與某種公開集會，他們可以輕易擠進一座長二十公里、寬二十公里的廣場，所有的人類甚至可以疊在太平洋最小的島嶼上。

當然囉，大人是不會相信這些話的。他們幻想自己佔了很大的空間，以為自己跟巴歐巴一樣重要；他們會勸你做算術，崇拜數字，數字令他們高興。但你不要浪費時間在這些無謂的作業，這是沒有用的，相信我吧！

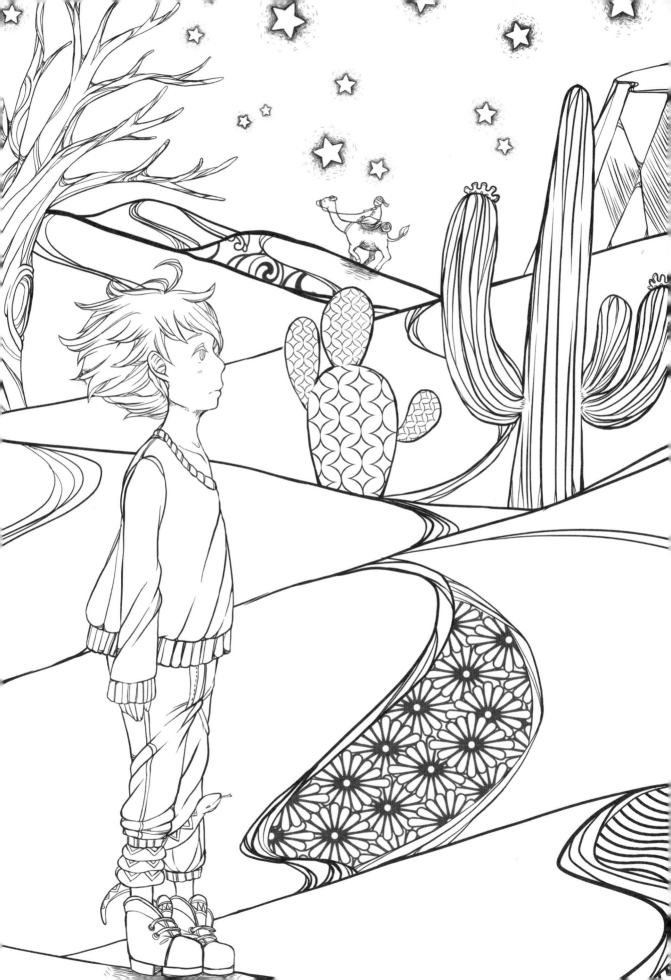

小王子降落於地球表面，很驚訝這裡沒有半個人，深怕自己走錯地方。他看到有一個指環在地上蠕動，透出月光的色澤，他脫口說出：「晚安！」

　　「晚安！」蛇說。

　　「這裡是哪個行星啊？」小王子問。

　　「是地球，這裡是地球的非洲。」蛇回答。

　　「啊……地球上都沒有人嗎？」

　　「這裡是沙漠，沙漠裡沒有人，地球是很大的。」蛇說。

　　小王子坐在一塊石頭上，抬頭望著天空。他說：「我常想星星總是在夜空中閃爍，是否是為了讓每個人終有一天都能找到屬於自己的那顆星。看看我的星！它剛好在我們的頭上呢……但是太遙遠了！」

　　「它很美。」蛇說：「你來這裡做什麼呢？」

　　「我和一朵花過不去。」小王子說。

　　「喔！」蛇叫了一聲，接著他倆沈默了一會兒。

　　終於，小王子開口問：「人類在哪裡？獨自待在沙漠有點寂寞。」

　　「在人群中也是寂寞的。」蛇說。

小王子凝視蛇許久。

他對蛇說：「你真是一種可笑的動物，像指頭那麼細。」

「但我比國王的指頭還厲害。」蛇回答。

小王子不禁笑開。

「你怎麼會很厲害……你連腳都沒有……甚至不能去旅行……」

「我能把你送到遠方，比船還厲害。」蛇說。

蛇纏上小王子的腳踝，像一條金腳鍊。

蛇又說：「我會把我碰到的東西，都送到他所來自的地方，但你很純潔，而且來自另一顆行星……」

小王子沒有回答。

「我很同情你，你是這麼的軟弱，孤伶伶地來到這顆花崗岩行星。我可以幫助你，如果有一天你很想念你的行星，我可以……」

小王子說：「喔！我了解你的意思，但是為什麼你講話總像謎語？」

「因為我能揭開所有謎底啊。」蛇說。

接著，他們不再說話。

Chapter 18

小王子橫越整片沙漠，只遇見一朵花 —— 一朵除了三片花瓣，什麼也沒有的花⋯⋯

「早安！」小王子說。

「早安！」花說。

「請問人類在哪裡呢？」小王子有禮貌地問。

那朵花曾經看見一隊駱駝商旅經過，她說：

「人類嗎？我相信他們存在於某個角落，有六個人或七個。好多年前我看過他們，但是沒人知道去哪裡可以找到他們。風帶走他們。他們沒有根，日子一定很難過。」

「再見！」小王子說。

「再見！」花說。

Chapter 19

　　後來小王子爬上一座高聳的山。他所認知的山，不過是那三座高度只到膝蓋的火山，他甚至把那座死火山當成凳子坐。於是他認為：「爬上這麼高的山，整個行星將一覽無遺，我將看見所有的人類……」但是，他只看到被歲月磨尖的懸岩峭壁。

　　「早安！」他下意識地說。
　　「早安……早安……」回音答話。
　　「你是誰啊？」小王子問。
　　「你是誰啊……你是誰啊……你是誰啊……」回音答話。
　　「做我的朋友吧，我很孤單。」小王子說。
　　「我很孤單……我很孤單……我很孤單……」回音答話。

　　小王子心想：「多麼奇怪的行星呀！到處都那麼乾燥、山壁峻峭、土壤鹹澀。人們缺乏想像力，只會一再重覆別人的話……我的行星上有一朵花，她總是先開口……」

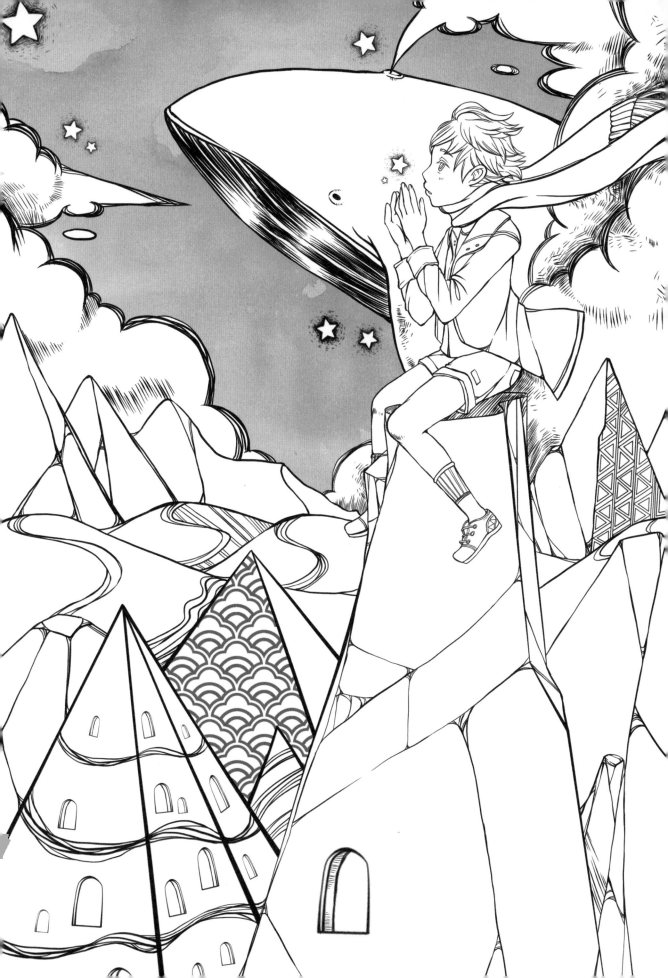

Chapter 20

　　小王子穿越沙丘、岩石和雪地，走了好久終於發現一條道路，而這條路通向人類居住的地方。

　　「午安？」小王子說。

　　他來到一座玫瑰盛放的花園。

　　「午安！」玫瑰花說。

　　小王子忍不住仔細觀察這些花，她們跟他的花長得好像。

　　「妳們是誰啊？」他驚訝地問。

　　「我們是玫瑰。」玫瑰花回答。

　　「喔……」小王子嘆息。

　　他很傷心……他的花曾說自己是全宇宙獨一無二的玫瑰，但光是這座花園就有五千朵跟她一模一樣的花。

他自言自語：「如果她看見這情景，一定會很懊惱。她將不停地咳嗽，為了逃避他人的嘲笑，她還會裝死。而我不得不假裝愛護她，否則她會真的一死了之……」

他又喃喃自語：「我以前曾因擁有一朵獨一無二的花，而自認為富有，其實我只是擁有一朵普通的玫瑰。擁有那朵花與那三座及膝的火山（其中一座甚至可能永遠不會爆發），不可能使我成為偉大的王子……」

於是小王子趴在草地上，哭了。

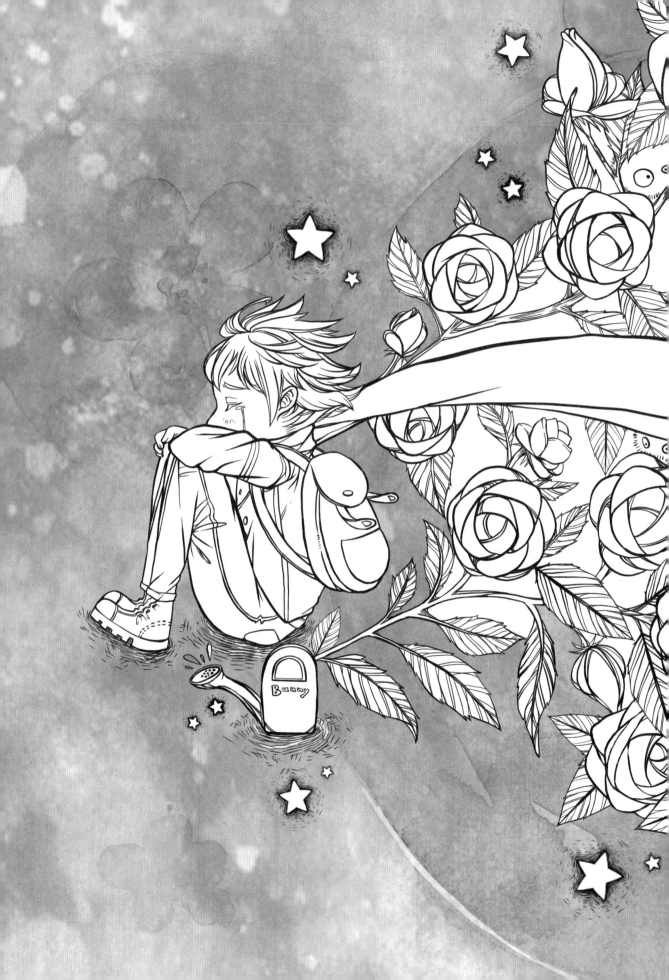

Chapter 21

此時，出現了一隻狐狸。

「你好！」狐狸說。

「你好！」小王子很有禮貌地回答，但他回過頭看，卻什麼也沒看見。

「我在這裡。」那道嗓音又響起：「在蘋果樹底下。」

「你是誰啊？」小王子問：「你長得滿好看的……」

「我是狐狸。」狐狸說。

「跟我玩，好嗎？」小王子建議。「我好不開心。」

狐狸說：「我不能跟你玩，我還沒被馴養。」

「啊，對不起！」小王子說。

但小王子想了一會兒，又問：

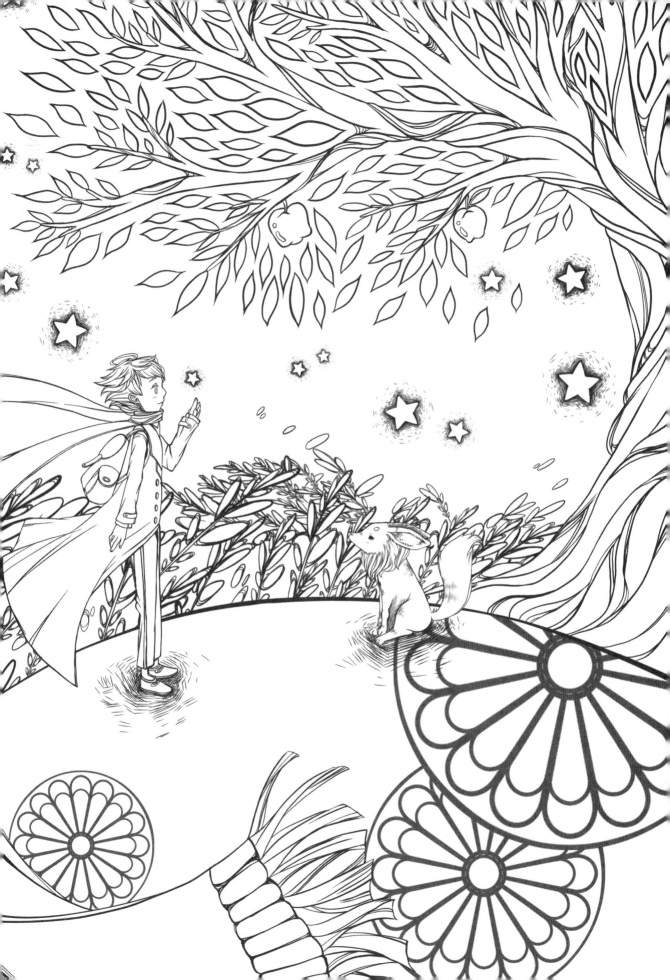

「什麼叫『馴養』？」

狐狸說：「你不是這裡的人吧？你在找什麼？」

「我在尋找人類。」小王子說：「什麼叫『馴養』呀？」

狐狸說：「人類嗎？他們有槍，他們打獵，非常討厭。但他們也養雞，這是他們唯一的優點。你在找雞嗎？」

小王子說：「不，我在找朋友。什麼叫『馴養』？」

「這是一件被遺忘的事。」狐狸說：「馴養就是『建立關係』……」

「建立關係？」

狐狸說：「沒錯。對我來說，你只不過是個小孩，跟其他成千上萬個小孩一樣，我不需要你，你也不需要我。我對你來說，只是一隻狐狸，跟其他成千上萬隻狐狸一模一樣。但是，假如你馴養我，我們就會需要彼此。對我來說，你將是獨一無二的；對你來說，我也是唯一的……」

「我好像懂了。」小王子說：「有一朵花……我想……她馴養了我……」

狐狸說：「這是有可能的。在地球上，我們看到的各種物體……」

「喔！她不在地球上。」小王子說。

狐狸很疑惑，牠問：「她在另外一顆行星上？」

「沒錯。」

「那顆行星上有獵人嗎？」

「沒有。」

「哈，這個好耶！有雞嗎？」

「沒有。」

「好吧，凡事都不完美。」狐狸嘆息。

但狐狸很快回到原來的話題：

「我的生活很單調，我獵捕雞，獵人獵捕我。所有的雞都是一樣的，所有的人也都一樣，這讓我有點不耐煩。但是，假如你馴養我，我的生活將會滿溢陽光。我將能夠辨別你的腳步聲，它有別於其他腳步聲。其他腳步聲使我躲進洞穴的深處，你的腳步聲則像樂曲，把我引出洞來。此外，你看！你有看見那邊的麥田嗎？我不吃麵包，麥子對我一點用處也沒有，完全不吸引我，這真悲哀。但是你有頭金髮，如果你馴養我，那些金色小麥將使我想起你，並且愛上聆聽拂過麥田的風聲……」

狐狸不再說話，牠凝視小王子良久。

牠說：「請你馴養我！」

「我很願意。」小王子回答：「但是我的時間不多，我要找朋友，還有很多事物等待我去了解。」

「一個人只需要了解他馴養的東西。」狐狸說：「多數人不再有時間去了解一樣東西，他們在商人那裡買現成品，但是商人不販賣朋友，所以很多人沒有朋友。假如你想得到一位朋友，就馴養我吧！」

「我該怎麼做？」小王子問。

狐狸回答：「你應該要很有耐心。你得先離我遠一點，像這樣，坐在草地上。我用眼角餘光看你，你不要說話，語言是誤會的根源。但是，每一天，你都可以坐得離我近一點……」

第二天小王子又來了。

狐狸對他說：「你最好每天同一時間來。因為，假如你下午四點來，從三點開始我就會感到幸福。時間越接近，我越幸福。四點一到，我早已坐立難安！我將發覺幸福的代價！但是如果你來的時間不固定，我不曉得什麼時候該做心理準備……我們應該定個儀式。」

「什麼儀式？」小王子問。

狐狸說：「那也是一件被人忘得一乾二淨的事。儀式就是有一個日子與其他日子不同，有段時間特別有意義，我們在這些時刻做不同的事。例如，我的獵人每週四都會和村裡的姑娘去跳舞，所以週四是個好日子！我可以一路散步去葡萄園。假如獵人跳舞的時間不固定，所有的日子將會一樣，而我也不會有假期。」

就這樣，小王子馴養了狐狸。

但兩人分離的時刻很快地到來，狐狸說：

「啊！我想哭。」

「都是你啦。」小王子說：「我不希望你難過，但是你要我馴養你。」

「沒錯。」狐狸說。

「但你現在卻想哭！」小王子說。

「沒錯。」狐狸說。

「這麼說來，你一點好處也沒得到啊！」

「我得到了。」狐狸說：「我已擁有小麥田的金黃色。」

狐狸又說：「你再去看看那些玫瑰。你將發現你的玫瑰是世界上唯一的一朵。

那時，你再回來跟我道別，我會告訴你一個祕密，作為臨別贈言。」

小王子跑去看那些玫瑰。

他對她們說：「妳們一點也不像我的玫瑰，妳們什麼也不是。沒有人馴養妳們，而妳們也沒有馴養過任何人。妳們就像以前的狐狸，當時牠跟其他成千上萬隻狐狸沒有兩樣，但是我們成了朋友，現在牠對我來說，是獨一無二的。」

那些玫瑰聽了很難過。

他又對她們說：「妳們都很美麗，但是很空虛，沒有人會為妳們而死。當然，一位普通的路人看到我的玫瑰，會認為她跟妳們一樣，但是對我來說，她比妳們重要。因為我為她澆水；因為把她罩進玻璃的是我；因為我獻給她一座屏風；因為我為她驅逐許多蛹（只留下兩三隻孵化成蝴蝶）；因為我聽過她的抱怨與吹噓；有些時候，我甚至看著她默不作聲，因為她是我的玫瑰。」

之後，小王子重新回到狐狸身邊。

「再見！」他說。

「再見！」狐狸說：「我的祕密很簡單……只有用心靈，人才能看得清楚。真正重要的東西，不是眼睛看得見的。」

「真正重要的東西，不是眼睛看得見的。」
小王子覆述，以便牢牢記在心底。

「你為你的玫瑰所花費的時間，使你的玫瑰變得重要。」
「我為我的玫瑰所花費的時間……」小王子覆述，以便牢牢記在心底。

狐狸說：「一般人早已忘記這個真理，但你不應該忘卻。你要永遠對你馴養的對象負責，尤其是對你的玫瑰……」

「我對我的玫瑰有責任……」小王子覆述，以便牢牢記在心底。

Chapter 22

「你好！」小王子說。

「你好！」火車調度員說。

「你在這裡做什麼？」小王子問。

「我在指引成千上萬的旅客。」火車調度員說：「我指揮承載旅客的火車，一會兒要它往右，一會兒要它往左。」

此時，剛好有一輛燈火通明的列車，像打雷一樣轟隆隆地駛來，把調度室震得嘎嘎作響。

小王子說：「他們看起來好匆忙，他們到底在找什麼？」

「這恐怕連火車駕駛員也不曉得。」調度員說。

轟隆隆──反向又駛來一輛列車。

「他們怎麼這麼快就回來了？」小王子問。

「這不是同一輛列車。」調度員說：「這是對向的另一輛列車。」

「他們不滿足於自己的所屬之地嗎？」

「從來沒有人安於自己的所屬之地。」調度員回答。

第三輛燈火通明的列車又轟隆隆地駛來。

小王子問：「他們在追第一輛列車的旅客嗎？」

「他們什麼也不追。」調度員說：「他們在裡面睡覺、打呵欠，只有小孩子把鼻頭頂在玻璃窗上。」

小王子說：「只有小孩子知道自己在找什麼。小孩子把時間花在拼布洋娃娃，使洋娃娃變得重要，假如有人把洋娃娃拿走，他們便大哭……」

「他們很幸福呢。」調度員說。

Chapter 23

「午安！」小王子說。

「午安！」商人回答。

　　這是一位賣解渴特效藥的商人，一個禮拜只要吞一顆他賣的藥，你整個禮拜就不必喝水。

　　「你為什麼賣這種東西？」小王子問。

　　「因為這很節省時間。」商人說：「根據專家統計，這藥可讓人一個禮拜節省五十三分鐘。」

　　「節省這五十三分鐘要做什麼？」

　　「看你高興做什麼就做什麼……」

　　「我嗎？」小王子自言自語：「如果我有五十三分鐘的空閒，我要從容地走向一汪泉水……」

Chapter 24

　　我的飛機在沙漠拋錨八天了，我一邊聽小王子說商人的故事，一邊喝掉我帶來的最後一滴水。

　　我對小王子說：「啊！你的回憶真美，但是我還沒修好飛機，而我一滴水也不剩了，假如我能從容地走向一汪泉水，我會很幸福！」

　　「我的朋友狐狸……」他對我說。
　　「我的小迷糊呀，這和狐狸沒有關係！」
　　「為什麼？」
　　「因為我們快要渴死了。」
　　他不懂我的論點。
　　他回答：「有朋友總是好的，即使你瀕臨死亡，而我嘛！我跟狐狸交了朋友，感到非常滿足……」

我自忖：「他一點危機意識也沒有，他從來不餓不渴，一絲陽光對他來說便已足夠……」

但是他卻盯著我，回應我心所想：

「我也口渴……我們去找一口井吧……」

我不耐煩地揮一揮手！在這廣闊的沙漠裡，找一口井哪有說的容易，但我們還是動身了，多不可思議。

我們一言不發地走了好幾個小時，直到夜幕低垂，星星開始閃爍。我因為缺水而有點發燒，那些星星就像夢中場景般恍惚。

小王子的話迴蕩於我的腦海……

「你也口渴嗎？你？」我問他。

但他不回答我的問題，只是簡短地說：

「或許水有益於心靈。」

我不明白他的話，但我沉默以對……我知道我不應該問他，他累了。

小王子坐下來，我坐在他旁邊。沈默了一會兒，他又說：

「那些星星很美，因為有一朵花藏在其中，而我們看不見……」

「當然。」我回答。

我靜靜地眺望月光下的沙丘。

「沙漠很美。」他又說了一句。

的確，我一直很喜歡沙漠。一個人坐在沙丘上，什麼也沒有，然而在這片寂靜中，有某些東西閃閃發光……

小王子說：「沙漠的美麗來自於，在沙漠某處藏了一口井……」

我恍然大悟，終於明白這片沙漠所散發的神祕光芒是什麼。我小時候住過一間古老的房子，傳說有寶藏埋在裡面，當然，從來沒有人知道那些寶藏埋在哪，甚至沒有人去找，可是這個傳說卻使整棟房子充滿神祕感。房子的深處藏了一個祕密……

「是的。」我告訴小王子：「不管是房子、星星或沙漠，使它們美麗的，都是看不見的東西！」

「我很高興。」他說：「你同意了狐狸。」

小王子睡著了，我把他抱進懷裡，再次上路。我很感動，好像自己正抱著一件易碎的寶物，我甚至覺得地球上再也沒有東西比他還脆弱。

沐浴於月亮的光輝，我凝視他蒼白的額頭、輕闔的眼皮，以及他那一頭猶如燈心草、在晚風中飄盪的輕柔髮絲。我喃喃自語：「我所看見的不過是表象，最重要的東西是看不見的……」

　　當那副半啟的小嘴唇展露似笑非笑的弧度，我又喃喃自語：「這位入睡的小王子使我感動，是因為他對一朵花的真誠，連他睡著的時候，那朵玫瑰的影像仍如燭光照耀著他……」不知不覺中，我覺得小王子變得更加脆弱了，我應該用心保護燭火般的他，因為一陣微風便足以將之熄滅……

　　我就這麼走著、走著，終於在破曉時分，發現一口井。

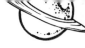

Chapter 25

小王子說：「那些人忙著擠進車廂，但是他們不曉得自己在找什麼。於是他們手忙腳亂地繞圈子……」

他又說：「這是何苦呢……」

我們找到的那口井不像撒哈拉沙漠的井。一般來說，撒哈拉沙漠的井只是個單調的洞，凹進沙地，而這口井很像村莊的井，但是這裡並沒有村莊。這使我覺得自己身陷夢境。

我對小王子說：「好奇怪，這裡連汲水工具都有，轆轤、水桶和繩子……」

他輕笑了，碰一碰繩子，轉一轉轆轤。

轆轤發出聲響，輕聲哼唱，好像一架古老的風向儀，在無風的日子微微哼著古調。

小王子說：「你聽，我們喚醒了這口井，它在歌唱……」
我不希望他太用力，於是開口：「讓我來吧！」
我說：「這個對你來說太重了。」

我緩緩地把水桶拉上來，放入一些重物。耳邊迴盪轆轤喀滋喀滋的歌聲，陽光使晃動的水面波光粼粼。

小王子說：「我口好渴，給我一些水……」
我這才明白他要的是什麼！

我把水桶提到他的嘴邊，他閉著眼睛啜飲。這一刻猶如慶典般甜蜜。這些水不僅解生理的渴，它還來自一段披星戴月的跋涉，來自轆轤的歌唱，來自我為小王子服務的臂膀。它猶如禮物，有益於心靈，一如聖誕樹上的燭光、午夜彌撒的樂曲，以及人們甜美的微笑，都使我兒時收到的聖誕禮物更加光彩奪目。

小王子說：「你們這裡的人在花園裡種五千株玫瑰……卻找不到自己要什麼……」

「對，他們找不到。」我回答。

小王子接著說：

「這麼說來，有時眼睛是盲目的，我們應該用心靈來尋找。」

我喝了一口水，呼吸變得順暢，沙漠在曙光的籠罩下，閃耀蜂蜜的金黃色。這顏色使我感到幸福，此刻我毫無所怨……

「你必須遵守你的諾言。」小王子坐回我的身邊，溫柔地對我說。

「什麼諾言？」

「你忘了嗎……你要為我畫一個綿羊嘴套……我對那朵花可是有責任的！」

我立刻從口袋掏出畫稿。小王子看了，忍不住笑出來：

「你的巴歐巴，看起來像高麗菜……」

「喔！」

我本來還以這棵巴歐巴為榮呢！

「你的狐狸……那雙耳朵……看起來像兩支角……太長了啦！」

我說：「你不公平，小王子，我本來就只會畫看得見內部和看不見內部的蟒蛇呀。」

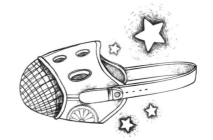

「喔！」他說：「那樣就夠了，小孩子會懂的。」

於是我用鉛筆畫了一個嘴套。我伸手遞給他，心緊緊地揪起。

「你是不是有事瞞著我……」
他不正面回應，只告訴我：
「你知道嗎？明天我降落於地球的時間，就滿一週年了……」
沈默了一會兒，他又說：
「我就是落在這附近……」
他臉紅了。

不知道為什麼，我再次湧上一股鼻酸。這讓我突然想起一個問題：
「這麼說來，八天前我遇見你的那個早上，你不是剛好在這杳無人煙的地方獨自走來走去，而是你想回到著陸地點？」
小王子的臉又紅了。

我猶豫了一會兒，又問：

「你是因為已經一週年了，所以才這麼做？……」

小王子變得滿臉通紅。他從來不回答別人的問題，但是，臉這麼紅就表示默認吧？

「啊！」我對他說：「我有點害怕……」
他卻打斷我：

「你現在應該回去工作，回去修你的引擎，我在這裡等你，我們明天傍晚再見面……」

但我不確定這是否為他的本意。我想起狐狸——若一個人被馴養，他有時會不自禁地落淚。

Chapter 26

　　水井旁邊有一截倒塌的石牆。第二天晚上，我完成工作，走近那片斷垣殘壁，遠遠就看到小王子兩腿垂掛，坐在高高的石牆上。我還聽到他在講話。

　　「你忘記了嗎？」他說：「這裡不是當初那個地方！」

　　無疑地，有另一道聲音回應了他，因為他急忙地答辯：

　　「沒錯！沒錯啦！是這一天，但不是在這個地方……」

　　我舉步，直直地往那座牆走去。我看不到其他人，也沒聽見有誰在講話，小王子卻再次答辯：

　　「不會錯的，你會看到我在沙地留下的第一個腳印。你只要在那裡等我就可以了，我今天晚上會過去。」

我只離那座牆二十公尺，但我仍然什麼也沒看到。

沈默了一會兒，小王子說：

「你有很厲害的毒液嗎？你確定我不會痛苦太久嗎？」

我愣了一下，停下腳步，仍舊抓不著頭緒。

「現在，你先走開吧！」他說：「我要下去了！」

我順勢看向牆腳，嚇了一大跳！牆腳竟然有一條高高豎起的黃蛇，正對著小王子。牠只需要三十秒鐘就可以葬送一條生命呀！

雖然我的手立刻探進口袋，摸索左輪手槍，但是我仍忍不住向後退了幾步。那條蛇似乎被我的聲音驚動，立刻如水滴般輕輕沒入沙底。牠不慌不忙地發出金屬摩擦的聲響，潛入小石堆。

我及時抵達那座牆，把我天真可愛的小王子抱進懷裡，只見他臉色蒼白如雪。

「這到底是怎麼一回事？你剛才在跟蛇講話！」

我鬆開他總是圍在脖子上的金黃色圍巾，以水沾濕他的太陽穴，餵他喝水。現在，我不敢再問他任何問題了。他深深地凝視我，用兩條臂膀圍住我的脖子，我察覺他的心跳很微弱，像被槍擊的小鳥，奄奄一息。

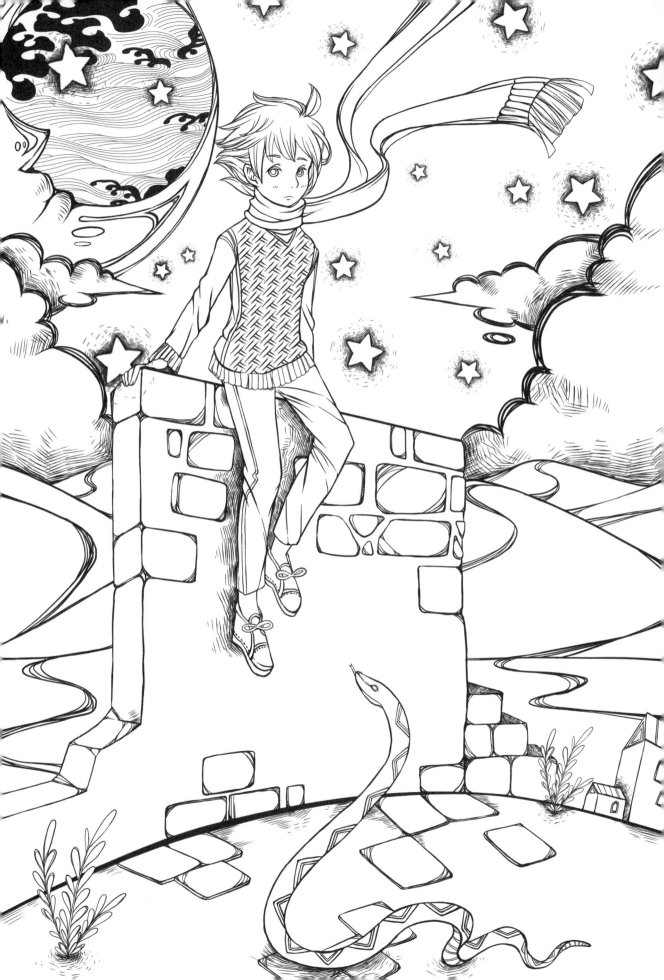

他對我說：「我很高興你找出引擎的毛病，你可以回你的老家了……」

「你怎麼知道？」

我正要來告訴他，經過各種嘗試，我終於完成了惱人的修繕工作。

他沒回答我的問題，只是接下去說：

「我也一樣……今天要回家了……」

接著，他傷感地說：

「路途更加遙遠……更加艱辛……」

我有強烈的預感，不尋常的事即將發生。我像抱嬰兒一樣，把他緊緊護在懷中，然而我總覺得他正逕自墮入深淵，我無能為力，拉不住他……

他的眼神異常嚴肅，茫然地注視遠方。他說：

「我有你送的綿羊，我有綿羊的箱子，也有嘴套……」

接著，他露出一抹哀傷的笑容。

我等了一段時間，才感覺他的身子慢慢回暖。

我說：「可憐的孩子，你受驚了……」

當然，他肯定嚇到了，但他溫柔地微笑道：

「今天晚上還有更可怕的呢……」

我再次被某種無力挽回的預感所凍結，我知道自己無法忍受再也聽不見這笑聲的想法。他的笑聲對我來說，就像荒漠中的甘泉。

　　「可愛的孩子，我想再聽一次你的笑聲……」
　　但是他說：
　　「今天晚上，就滿一週年了，我的星星會剛好在著陸地點的正上方……」
　　「可愛的孩子，告訴我這是一場惡夢吧——那條蛇的事、你們的約定，以及那顆星星……」

　　但是他不回應我的請求，反之，他告訴我：
　　「真正重要的，是我們看不見的東西……」
　　「是的，我知道……」
　　「就好像擁有一朵花。假如你喜歡一朵花，她長於某一顆星星，那麼仰望星空將使你滿心甜蜜，所有的星星都如花盛開……」
　　「是的，我知道……」

　　「水也是如此，因為轆轤和繩子發出的聲音，你給我喝的水就像音樂……你記得吧——那些水有多美好。」
　　「我知道，我知道……」

「而後，你將在夜晚仰望星空。我的行星太小，沒辦法指給你看在哪裡，但這樣也好。對你來說，我的行星將是眾星之一，於是你會愛上仰望天上繁星……它們都將成為你的朋友……對了，我還要送你一件禮物……」

他又笑了。

「啊！可愛的孩子、可愛的孩子，我喜歡這笑聲！」
「這就是我的禮物……猶如那些水……」
「什麼意思？」

「所有人都能擁有星星，但星星對每個人的意義都不同。對旅人來說，星星是他們的嚮導；對一般人來說，星星只是微弱的亮光；對科學家來說，星星是待解的謎題；對我認識的實業家來說，星星是財富。但是他們所擁有的星星都默不作聲，只有你，你將擁有別人所沒有的星星……」

「這是什麼意思？」

「當你仰望星空，因為我住在其中一顆星，因為我將在其中一顆星上笑，於是對你來說，彷彿所有的星星都在笑。也就是說，你——只有你，擁有會笑的星星！」

說完，他又笑了。

「將來，當你的悲傷已被撫慰（時間會撫慰一切），你將因認識我而滿足。你永遠是我的朋友。你會想跟我一起笑，因此有時你會為了好玩而打開窗子……你的朋友會驚訝地看到你望著天空發笑，你會對他們說『是的，那些星星常逗我笑！』他們必定認為你瘋了，那將是我對你開的小玩笑……」

他又笑了。

「這就好像，我不是給了你一堆星星，而是給了你許多會笑的小鈴鐺……」

他笑著笑著，突然板起臉來：

「今天晚上……你知道的……不要來找我。」

「我不願離開你。」我說。

「我會看起來很痛苦……像要邁向死亡一樣。沒錯，我看起來會像那樣。你不要來看那一幕，沒什麼好看的……」

「我不願離開你。」我堅持。

他看起來是那麼地憂心。

「我告訴你……我不要你來的原因還包括那條蛇，我不應該讓牠有機會咬你……蛇是陰險的，牠們可能為了玩樂而咬人……」

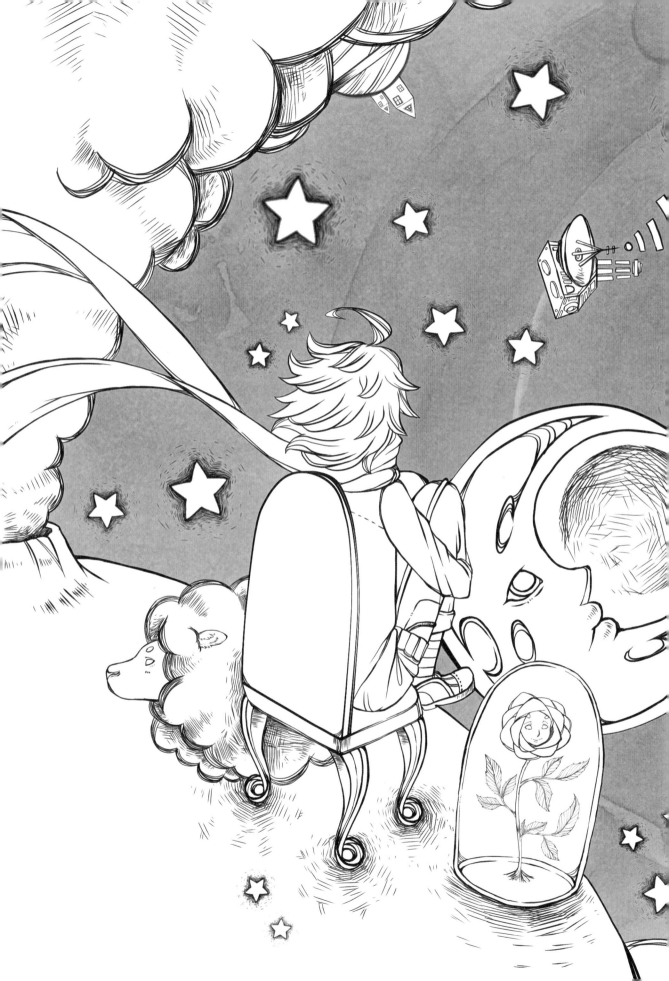

「我不要離開你！」我大喊。

忽然，他靈光一閃，安下心來：

「對了，牠咬了我，所剩的毒液就不夠牠傷害第二個人了……」

那天晚上我沒有親眼看到他啟程，他無聲無息地離開了我。我終於追上他的時候，他正毫不猶豫地快步行走，只對我說：

「啊！你來啦……」

他牽起我的手，但他仍舊憂心地說：

「你不該來的。你會很難過。我看起來會像死去一樣，但這不是真的……」

我沉默。

「你懂嗎？路途太遙遠了，我沒辦法帶走我的軀殼，太重了。」

我沉默。

「這就像丟棄一個舊殼，丟掉舊殼並不值得傷心……」

我仍舊沉默。

面對我的反應，他有點氣餒，但他隨即鼓起勇氣安慰我：

「你想想，這是很棒的一件事，我也會看向群星。我眼中的星星都是擁有生鏽轆轤的井，所有星星都會為我傾注甘泉……」

我一言不發。

「這很好玩吧！你有五億顆小鈴鐺，我有五億口井……」
最後，他也靜了下來，因為他已泣不成聲……

「就是那裡，讓我獨自走向那裡吧。」
但他卻坐了下來，因為他其實也感到害怕。

他又說：
「你知道……我的花……我對她有責任。她那麼軟弱！那麼天真！
她只能以四支沒用的芒刺來對抗世界……」

我也坐下來，因為我再也無力站直。
他說：「就這樣……事情就是這樣……」
他又猶豫了一會兒，最後站起身，向前走了一步。我無力動彈。

他站立的地方什麼都沒有，只有那圈在他腳踝附近的金色光輝。他
一動也不動地佇立一陣子，並沒有哭出來。他像棵樹輕輕倒下，沙地甚
至抹去了所有聲響……

Chapter 27

　　如今，已過了六年……我從來沒有將這個故事告訴別人。歡迎我平安歸來的夥伴，都對我的生還嘖嘖稱奇。但我很哀傷，只是淡淡地告訴他們，我累了。

　　現在我已多多少少得到時間的撫慰，也就是說，我並沒有完全被撫慰。但是我清楚知道，小王子已回到他的行星，因為他離去的隔天黎明，我找不到他的屍體，可見那不是一副很重的軀殼啊……而我喜歡在晚上聆聽那些星星，它們像五億顆小鈴鐺……

　　不過，有個意外的小插曲……我為小王子畫的嘴套，忘了裝皮帶！它永遠無法牢固地套在綿羊身上，所以我不斷地想：「在那顆行星上，發生了什麼事？或許那隻綿羊早已吃掉那朵花……」

有時候我會想：「絕對不會！小王子每天晚上都會把他的花罩進玻璃，而且他會好好地看守那隻綿羊……」這讓我感到幸福，彷彿所有的星星都在溫柔微笑。

　　但是有時我又想：「人總是會疏忽，而且只要疏忽一兩次就慘了！也許他某天晚上會忘記罩玻璃罩，或許那隻綿羊有一天晚上會無聲無息地跑到外面……」這麼一想，天上的小鈴鐺又會變成一滴滴的淚珠……

　　這真是神奇，對我以及同樣喜歡小王子的你來說，在那未知的某處，不管那隻我們不曾見過的綿羊，是否有吃掉那朵玫瑰花，整座宇宙都已不再一樣……

　　仰望天空吧！請你問自己：「吃了嗎？那隻綿羊是否吃了那朵花？」你將看到一切都變得不一樣……

　　而大人永遠不會明白這有多麼重要！

對我來說，這就是世界上最美麗，也最悲傷的風景。這與上一頁所畫的圖一樣，但是我要再畫一次，讓你深深地印在腦海——就在這裡，小王子出現在地球上，又消失了。

　　請你再仔細看看這風景，如此一來，如果你有機會去非洲沙漠旅行，你才能認出這個地點。若你正巧經過那裡，請不要走得太匆忙，請你在星光下等一會兒！假如那個時候，有一位小孩走近你，他笑著，而且擁有一頭金色頭髮，怎麼也不回答你的問題——你必定猜得到他是誰吧！那時，拜託你做點好事，給我一點慰藉，寫信告訴我，他回來了。

Chapter 1

Once when I was six years old I saw a magnificent picture in a book, called True Stories from Nature, about the primeval forest. It was a picture of a boa constrictor in the act of swallowing an animal. Here is a copy of the drawing.

In the book it said: "Boa constrictors swallow their prey whole, without chewing it. After that they are not able to move, and they sleep through the six months that they need for digestion." I pondered deeply, then, over the adventures of the jungle. And after some work with a colored pencil I succeeded in making my first drawing. My Drawing Number One. It looked like this:

I showed my masterpiece to the grown-ups, and asked them whether the drawing frightened them. But they answered: "Frighten? Why should anyone be frightened by a hat? "My drawing was not a picture of a hat. It was a picture of a boa constrictor digesting an elephant. But since the grown-ups were not able to understand it, I made another drawing: I drew the inside of the boa constrictor, so that the grown-ups could see it clearly. They always need to have things explained.

My Drawing Number Two looked like this:

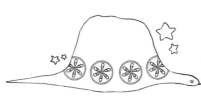

The grown-ups' response' this time, was to advise me to lay aside my drawings of boa constrictors, whether from the inside or the outside, and devote myself instead to geography, history, arithmetic and grammar. That is why, at the age of six, I gave up what might have been a magnificent career as a painter. I had been disheartened by the failure of my Drawing Number One and my Drawing Number Two. Grown-ups never understand

anything by themselves, and it is tiresome for children to be always and forever explaining things to them.

So then I chose another profession, and learned to pilot airplanes. I have flown a little over all parts of the world; and it is true that geography has been very useful to me. At a glance I can distinguish China from Arizona. If one gets lost in the night, such knowledge is valuable. In the course of this life I have had a great many encounters with a great many people who have been concerned with matters of consequence. I have lived a great deal among grown-ups. I have seen them intimately, close at hand. And that hasn't much improved my opinion of them.

Whenever I met one of them who seemed to me at all clear-sighted, I tried the experiment of showing him my Drawing Number One, which I have always kept. I would try to find out, so, if this was a person of true understanding. But, whoever it was, he, or she, would always say: "That is a hat." Then I would never talk to that person about boa constrictors, or primeval forests, or stars. I would bring myself down to his level. I would talk to him about bridge, and golf, and politics, and neckties. And the grown-up would be greatly pleased to have met such a sensible man.

Chapter 2

So I lived my life alone, without anyone that I could really talk to, until I had an accident with my plane in the Desert of Sahara, six years ago. Something was broken in my engine. And as I had with me neither a mechanic nor any passengers, I set myself to attempt the difficult repairs all alone. It was a question of life or death for me: I had scarcely enough drinking water to last a week.

The first night, then, I went to sleep on the sand, a thousand miles from any human habitation. I was more isolated than a shipwrecked sailor on a

raft in the middle of the ocean. Thus you can imagine my amazement, at sunrise, when I was awakened by an odd little voice.

It said: "If you please, draw me a sheep! "

"What! "

"Draw me a sheep! "

I jumped to my feet, completely thunderstruck. I blinked my eyes hard. I looked carefully all around me. And I saw a most extraordinary small person, who stood there examining me with great seriousness. Here you may see the best potrait that, later, I was able to make of him. But my drawing is certainly very much less charming than its model.

That, however, is not my fault. The grown-ups discouraged me in my painter's career when I was six years old, and I never learned to draw anything, except boas from the outside and boas from the inside.

Now I stared at this sudden apparition with my eyes fairly starting out of my head in astonishment. Remember, I had crashed in the desert a thousand miles from any inhabited region. And yet my little man seemed neither to be straying uncertainly among the sands, nor to be fainting from fatigue or hunger or thirst or fear. Nothing about him gave any suggestion of a child lost in the middle of the desert, a thousand miles from any human habitation.

When at last I was able to speak, I said to him: "But, what are you doing here? " And in answer he repeated, very slowly, as if he were speaking of a matter of great consequence:

"If you please, draw me a sheep..."

When a mystery is too overpowering, one dare not disobey. Absurd as it might seem to me, a thousand miles from any human habitation and in danger of death, I took out of my pocket a sheet of paper and my fountain-pen. But then I remembered how my studies had been concentrated on geography, history, arithmetic, and grammar, and I told the little chap (a little crossly, too) that I did not know how to draw. He answered me: "That doesn't matter. Draw me a sheep... " But I had never drawn a sheep. So I drew for him one of the two pictures I had drawn so often. It was that of the boa constrictor from the outside. And I was astounded to hear the little fellow greet it with, "No, no, no! I do not want an elephant inside a boa constrictor. A boa constrictor is a very dangerous creature, and an elephant is very cumbersome. Where I live, everything is very small. What I need is a sheep. Draw me a sheep. "

So then I made a drawing. He looked at it carefully, then he said: "No. This sheep is already very sickly. Make me another. " So I made another drawing. My friend smiled gently and indulgently. "You see yourself, " he said, "that this is not a sheep. This is a ram. It has horns. "

So then I did my drawing over once more. But it was rejected too, just like the others. "This one is too old. I want a sheep that will live a long time. "

By this time my patience was exhausted, because I was in a hurry to start taking my engine apart. So I tossed off this drawing. And I threw out an explanation with it.

"This is only his box. The sheep you asked for is inside. "

138

I was very surprised to see a light break over the face of my young judge:

"That is exactly the way I wanted it! Do you think that this sheep will have to have a great deal of grass?"

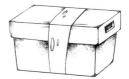

"Why?"

"Because where I live everything is very small..."

"There will surely be enough grass for him," I said. "It is a very small sheep that I have given you."

He bent his head over the drawing: "Not so small that, Look! He has gone to sleep..." And that is how I made the acquaintance of the little prince.

Chapter 3

It took me a long time to learn where he came from. The little prince, who asked me so many questions, never seemed to hear the ones I asked him. It was from words dropped by chance that, little by little, everything was revealed to me.

The first time he saw my airplane, for instance (I shall not draw my airplane; that would be much too complicated for me), he asked me: "What is that object?"

"That is not an object. It flies. It is an airplane. It is my airplane." And I was proud to have him learn that I could fly. He cried out, then: "What! You dropped down from the sky?"

"Yes." I answered, modestly.

"Oh! That is funny! "

And the little prince broke into a lovely peal of laughter, which irritated me very much. I like my misfortunes to be taken seriously.

Then he added: "So you, too, come from the sky! Which is your planet? " At that moment I caught a gleam of light in the impenetrable mystery of his presence; and I demanded, abruptly: "Do you come from another planet? " But he did not reply. He tossed his head gently, without taking his eyes from my plane: "It is true that on that you can't have come from very far away... " And he sank into a reverie, which lasted a long time. Then, taking my sheep out of his pocket, he buried himself in the contemplation of his treasure.

You can imagine how my curiosity was aroused by this half-confidence about the "other planets". I made a great effort, therefore, to find out more on this subject.

"My little man, where do you come from? What is this 'where I live, ' of which you speak? Where do you want to take your sheep? "

After a reflective silence he answered: "The thing that is so good about the box you have given me is that at night he can use it as his house. "

"That is so. And if you are good I will give you a string, too, so that you can tie him during the day, and a post to tie him to. "

But the little prince seemed shocked by this offer: "Tie him! What a queer idea! "

"But if you don't tie him, "I said: "he will wander off somewhere, and get lost. "

My friend broke into another peal of laughter: "But where do you think he would go? " "Anywhere. Straight ahead of him. "

Then the little prince said, earnestly: "That doesn't matter. Where I live, everything is so small! " And, with perhaps a hint of sadness, he added: "Straight ahead of him, nobody can go very far... "

Chapter 4

I had thus learned a second fact of great importance: this was that the planet the little prince came from was scarcely any larger than a house! But that did not really surprise me much. I knew very well that in addition to the great planets, such as the Earth, Jupiter, Mars, Venus, to which we have given names, there are also hundreds of others, some of which are so small that one has a hard time seeing them through the telescope.

When an astronomer discovers one of these he does not give it a name, but only a number. He might call it, for example, "Asteroid 325. "

I have serious reason to believe that the planet from which the little prince came is the asteroid known as B-612. This asteroid has only once been seen through the telescope. That was by a Turkish astronomer, in 1909. On making his discovery, the astronomer had presented it to the International Astronomical Congress, in a great demonstration. But he was in Turkish costume, and so nobody would believe what he said. Grown-ups are like that...

Fortunately, however, for the reputation of Asteroid B-612, a Turkish dictator made a law that his subjects, under pain of death, should change to European costume. So in 1920 the astronomer gave his demonstration

all over again, dressed with impressive style and elegance. And this time everybody accepted his report.

If I have told you these details about the asteroid, and made a note of its number for you, it is on account of the grown-ups and their ways. When you tell them that you have made a new friend, they never ask you any questions about essential matters. They never say to you, "What does his voice sound like? What games does he love best? Does he collect butterflies? " Instead, they demand: "How old is he? How many brothers has he? How much does he weigh? How much money does his father make?"

Only from these figures do they think they have learned anything about him.

If you were to say to the grown-ups: "I saw a beautiful house made of rosy brick, with geraniums in the windows and doves on the roof," they would not be able to get any idea of that house at all.
 You would have to say to them: "I saw a house that cost a hundred thousand francs." Then they would exclaim: "Oh, what a pretty house that is!" Just so, you might say to them: "The proof that the little prince existed is that he was charming, that he laughed, and that he was looking for a sheep. If anybody wants a sheep, that is a proof that he exists." And what good would it do to tell them that? They would shrug their shoulders, and treat you like a child. But if you said to them: "The planet he came from is Asteroid B-612", then they would be convinced, and leave you in peace from their questions. They are like that. One must not hold it against them. Children should always show great forbearance toward grown-up people. But certainly, for us who understand life, figures are a matter of indifference.

I should have liked to begin this story in the fashion of the fairy tales. I should have like to say: "Once upon a time there was a little prince who lived on a planet that was scarcely any bigger than himself, and who had need of a sheep..."

To those who understand life, that would have given a much greater air of truth to my story. For I do not want anyone to read my book carelessly. I have suffered too much grief in setting down these memories. Six years have already passed since my friend went away from me, with his sheep. If I try to describe him here, it is to make sure that I shall not forget him. To forget a friend is sad. Not everyone has had a friend. And if I forget him, I may become like the grown-ups who are no longer interested in anything but figures... It is for that purpose, again, that I have bought a box of paints and some pencils.

It is hard to take up drawing again at my age, when I have never made any pictures except those of the boa constrictor from the outside and the boa constrictor from the inside, since I was six. I shall certainly try to make my portraits as true to life as possible. But I am not at all sure of success. One drawing goes along all right, and another has no resemblance to its subject. I make some errors, too, in the little prince's height: in one place he is too tall and in another too short. And I feel some doubts about the color of his costume. So I fumble along as best I can, now good, now bad, and I hope generally fair-to-middling. In certain more important details I shall make mistakes, also. But that is something that will not be my fault. My friend never explained anything to me. He thought, perhaps, that I was like himself. But I, alas, do not know how to see sheep through t he walls of boxes. Perhaps I am a little like the grown-ups. I have had to grow old.

Chapter 5

As each day passed I would learn, in our talk, something about the little prince's planet, his departure from it, his journey. The information would come very slowly, as it might chance to fall from his thoughts. It was in this way that I heard, on the third day, about the catastrophe of the baobabs.

This time, once more, I had the sheep to thank for it. For the little prince asked me abruptly, as if seized by a grave doubt,

"It is true, isn't it, that sheep eat little bushes?"

"Yes, that is true. "

"Ah! I am glad! "

I did not understand why it was so important that sheep should eat little bushes. But the little prince added: "Then it follows that they also eat baobabs? " I pointed out to the little prince that baobabs were not little bushes, but, on the contrary, trees as big as castles; and that even if he took a whole herd of elephants away with him, the herd would not eat up one single baobab.

The idea of the herd of elephants made the little prince laugh. "We would have to put them one on top of the other," he said. But he made a wise comment:

"Before they grow so big, the baobabs start out by being little."

"That is strictly correct," I said. "But why do you want the sheep to eat the little baobabs?"

He answered me at once, "Oh, come, come!" ,as if he were speaking of something that was self-evident. And I was obliged to make a great mental effort to solve this problem, without any assistance.

Indeed, as I learned, there were on the planet where the little prince lived, as on all planets, good plants and bad plants. In consequence, there were good seeds from good plants, and bad seeds from bad plants. But

seeds are invisible. They sleep deep in the heart of the earth's darkness, until someone among them is seized with the desire to awaken. Then this little seed will stretch itself and begin, timidly at first, to push a charming little sprig inoffensively upward toward the sun. If it is only a sprout of radish or the sprig of a rose-bush, one would let it grow wherever it might wish. But when it is a bad plant, one must destroy it as soon as possible, the very first instant that one recognizes it.

Now there were some terrible seeds on the planet that was the home of the little prince; and these were the seeds of the baobab. The soil of that planet was infested with them. A baobab is something you will never, never be able to get rid of if you attend to it too late. It spreads over the entire planet. It bores clear through it with its roots. And if the planet is too small, and the baobabs are too many, they split it in pieces...

"It is a question of discipline," the little prince said to me later on.

"When you've finished your own toilet in the morning, then it is time to attend to the toilet of your planet, just so, with the greatest care. You must see to it that you pull up regularly all the baobabs, at the very first moment when they can be distinguished from the rosebushes which they resemble so closely in their earliest youth. It is very tedious work, " the little prince added, "but very easy." And one day he said to me: "You ought to make a beautiful drawing, so that the children where you live can see exactly how all this is. That would be very useful to them if they were to travel some day.

"Sometimes," he added, "there is no harm in putting off a piece of work until another day. But when it is a matter of baobabs, that always means a catastrophe. I knew a planet that was inhabited by a lazy man. He neglected three little bushes..."

So, as the little prince described it to me, I have made a drawing of that planet. I do not much like to take the tone of a moralist. But the danger of the baobabs is so little understood, and such considerable risks would be run

by anyone who might get lost on an asteroid, that for once I am breaking through my reserve. "Children," I say plainly, "watch out for the baobabs!" My friends, like myself, have been skirting this danger for a long time, without ever knowing it; and so it is for them that I have worked so hard over this drawing.

The lesson which I pass on by this means is worth all the trouble it has cost me. Perhaps you will ask me, "Why are there no other drawing in this book as magnificent and impressive as this drawing of the baobabs?" The reply is simple. I have tried. But with the others I have not been successful. When I made the drawing of the baobabs I was carried beyond myself by the inspiring force of urgent necessity.

Chapter 6

Oh, little prince! Bit by bit I came to understand the secrets of your sad little life... For a long time you had found your only entertainment in the quiet pleasure of looking at the sunset.

I learned that new detail on the morning of the fourth day, when you said to me:

"I am very fond of sunsets. Come, let us go look at a sunset now. "

"But we must wait," I said.

"Wait? For what? "

"For the sunset. We must wait until it is time. "

At first you seemed to be very much surprised. And then you laughed to

yourself. You said to me: "I am always thinking that I am at home!"

Just so. Everybody knows that when it is noon in the United States the sun is setting over France. If you could fly to France in one minute, you could go straight into the sunset, right from noon. Unfortunately, France is too far away for that. But on your tiny planet, my little prince, all you needed to do is move your chair a few steps. You can see the day end and the twilight falling whenever you like...

"One day," you said to me, "I saw the sunset forty-four times!"

And a little later you added:

"You know, one loves the sunset, when one is so sad..."

"Were you so sad, then?" I asked, "on the day of the forty-four sunsets?"

But the little prince made no reply.

Chapter 7

On the fifth day—again, as always, it was thanks to the sheep— the secret of the little prince's life was revealed to me. Abruptly, without anything to lead up to it, and as if the question had been born of long and silent meditation on his problem, he demanded:

"A sheep— if it eats little bushes, does it eat flowers, too?"

"A sheep," I answered, "eats anything it finds in its reach."

"Even flowers that have thorns?"

"Yes, even flowers that have thorns."

"Then the thorns– what use are they?"

I did not know. At that moment I was very busy trying to unscrew a bolt that had got stuck in my engine. I was very much worried, for it was becoming clear to me that the breakdown of my plane was extremely serious. And I had so little drinking-water left that I had to fear for the worst.

"The thorns– what use are they?"

The little prince never let go of a question, once he had asked it. As for me, I was upset over that bolt. And I answered with the first thing that came into my head:

"The thorns are of no use at all. Flowers have thorns just for spite!"

"Oh!"

There was a moment of complete silence. Then the little prince flashed back at me, with a kind of resentfulness:

"I don't believe you! Flowers are weak creatures. They are naïve. They reassure themselves as best they can. They believe that their thorns are terrible weapons... "

I did not answer. At that instant I was saying to myself: "If this bolt still won't turn, I am going to knock it out with the hammer." Again the little prince disturbed my thoughts.

"And you actually believe that the flowers–"

"Oh, no!" I cried. "No, no no! I don't believe anything. I answered you with the first thing that came into my head. Don't you see– I am very busy with matters of consequence!"

He stared at me, thunderstruck.

"Matters of consequence!"

He looked at me there, with my hammer in my hand, my fingers black with engine-grease, bending down over an object which seemed to him extremely ugly...

"You talk just like the grown-ups!"

That made me a little ashamed. But he went on, relentlessly:

"You mix everything up together... You confuse everything..."

He was really very angry. He tossed his golden curls in the breeze.

"I know a planet where there is a certain red-faced gentleman. He has never smelled a flower. He has never looked at a star. He has never loved any one. He has never done anything in his life but add up figures. And all day he says over and over, just like you: 'I am busy with matters of consequence!' And that makes him swell up with pride. But he is not a man-- he is a mushroom! "

"A what?"

"A mushroom!"

The little prince was now white with rage.

"The flowers have been growing thorns for millions of years. For millions of years the sheep have been eating them just the same. And is it not a matter of consequence to try to understand why the flowers go to so much trouble to grow thorns which are never of any use to them? Is the warfare between the sheep and the flowers not important? Is this not of more consequence than a fat red-faced gentleman's sums? And if I know—I, myself– one flower which is unique in the world, which grows nowhere but on my planet, but which one little sheep can destroy in a single bite some morning, without even noticing what he is doing– Oh! You think that is not important!"

His face turned from white to red as he continued:

"If someone loves a flower, of which just one single blossom grows in all the millions and millions of stars, it is enough to make him happy just to look at the stars. He can say to himself, 'Somewhere, my flower is there...' But if the sheep eats the flower, in one moment all his stars will be darkened... And you think that is not important!"

He could not say anything more. His words were choked by sobbing...

The night had fallen. I had let my tools drop from my hands. Of what moment now was my hammer, my bolt, or thirst, or death? On one star, one planet, my planet, the Earth, there was a little prince to be comforted. I took him in my arms, and rocked him. I said to him:

"The flower that you love is not in danger. I will draw you a muzzle for your sheep. I will draw you a railing to put around your flower. I will–"

I did not know what to say to him. I felt awkward and blundering. I did not know how I could reach him, where I could overtake him and go on hand in hand with him once more.

It is such a secret place, the land of tears.

Chapter 8

I soon learned to know this flower better. On the little prince's planet the flowers had always been very simple. They had only one ring of petals; they took up no room at all; they were a trouble to nobody. One morning they would appear in the grass, and by night they would have faded peacefully away. But one day, from a seed blown from no one knew where, a new flower had come up; and the little prince had watched very closely over this small sprout which was not like any other small sprouts on his planet.

It might, you see, have been a new kind of baobab. The shrub soon stopped growing, and began to get ready to produce a flower. The little prince, who was present at the first appearance of a huge bud, felt at once that some sort of miraculous apparition must emerge from it. But the flower was not satisfied to complete the preparations for her beauty in the shelter of her green chamber. She chose her colours with the greatest care. She adjusted her petals one by one. She did not wish to go out into the world all rumpled, like the field poppies. It was only in the full radiance of her beauty that she wished to appear. Oh, yes! She was a coquettish creature! And her mysterious adornment lasted for days and days. Then one morning, exactly at sunrise, she suddenly showed herself. And, after working with all this painstaking precision, she yawned and said: "Ah! I am scarcely awake. I beg that you will excuse me. My petals are still all disarranged... " But the little prince could not restrain his admiration:

"Oh! How beautiful you are! "

"Am I not?" the flower responded, sweetly.

"And I was born at the same moment as the sun..."

The little prince could guess easily enough that she was not any too modest, but how moving, and exciting she was!

"I think it is time for breakfast," she added an instant later. "If you would have the kindness to think of my needs," And the little prince, completely abashed, went to look for a sprinkling can of fresh water.

So, he tended the flower. So, too, she began very quickly to torment him with her vanity, which was, if the truth be known, a little difficult to deal with.

One day, for instance, when she was speaking of her four thorns, she said to the little prince: "Let the tigers come with their claws!"

"There are no tigers on my planet," the little prince objected. "And, anyway, tigers do not eat weeds."

"I am not a weed," the flower replied, sweetly. "Please excuse me... " "I am not at all afraid of tigers," she went on, "but I have a horror of drafts. I suppose you wouldn't have a screen for me? "

"A horror of drafts, that is bad luck, for a plant," remarked the little prince, and added to himself," This flower is a very complex creature..."

"At night I want you to put me under a glass globe. It is very cold where you live. In the place I came from..." But she interrupted herself at that point. She had come in the form of a seed. She could not have known anything of any other worlds.

Embarrassed over having let herself be caught on the verge of such an untruth, she coughed two or three times, in order to put the little prince in the wrong.

"The screen?"

"I was just going to look for it when you spoke to me... "

Then she forced her cough a little more so that he should suffer from remorse just the same. So the little prince, in spite of all the good will that was inseparable from his love, had soon come to doubt her. He had taken seriously words which were without importance, and it made him very unhappy.

"I ought not to have listened to her," he confided to me one day.

"One never ought to listen to the flowers. One should simply look at them and breathe their fragrance. Mine perfumed all my planet. But I did not know how to take pleasure in all her grace. This tale of claws, which disturbed me so much, should only have filled my heart with tenderness and pity."

And he continued his confidences: "The fact is that I did not know how to understand anything! I ought to have judged by deeds and not by words. She cast her fragrance and her radiance over me. I ought never to have run away from her... I ought to have guessed all the affection that lay behind her poor little stratagems. Flowers are so inconsistent! But I was too young to know how to love her..."

Chapter 9

I believe that for his escape he took advantage of the migration of a flock of wild birds. On the morning of his departure he put his planet in perfect order. He carefully cleaned out his active volcanoes. He possessed two active

volcanoes; and they were very convenient for heating his breakfast in the morning.

He also had one volcano that was extinct. But, as he said, "One never knows!" So he cleaned out the extinct volcano, too. If they are well cleaned out, volcanoes burn slowly and steadily, without any eruptions. Volcanic eruptions are like fires in a chimney.

On our earth we are obviously much too small to clean out our volcanoes. That is why they bring no end of trouble upon us. The little prince also pulled up, with a certain sense of dejection, the last little shoots of the baobabs. He believed that he would never want to return. But on this last morning all these familiar tasks seemed very precious to him. And when he watered the flower for the last time, and prepared to place her under the shelter of her glass globe, he realised that he was very close to tears. "Goodbye," he said to the flower. But she made no answer. "Goodbye," he said again. The flower coughed. But it was not because she had a cold.

"I have been silly," she said to him, at last. "I ask your forgiveness. Try to be happy..." He was surprised by this absence of reproaches. He stood there all bewildered, the glass globe held arrested in mid-air. He did not understand this quiet sweetness.

"Of course I love you," the flower said to him. "It is my fault that you have not known it all the while. That is of no importance. But you, you have been just as foolish as I. Try to be happy... let the glass globe be. I don't want it anymore."

"But the wind..." "My cold is not so bad as all that... the cool night air will do me good. I am a flower."

"But the animals...""Well, I must endure the presence of two or three caterpillars if I wish to become acquainted with the butterflies. It seems that

they are very beautiful. And if not the butterflies and the caterpillars who will call upon me? You will be far away... as for the large animals, I am not at all afraid of any of them. I have my claws."

And, naively, she showed her four thorns.

Then she added: "Don't linger like this. You have decided to go away. Now go! "

For she did not want him to see her crying. She was such a proud flower...

Chapter 10

He found himself in the neighborhood of the asteroids 325, 326, 327, 328, 329, and 330. He began, therefore, by visiting them, in order to add to his knowledge.

The first of them was inhabited by a king. Clad in royal purple and ermine, he was seated upon a throne which was at the same time both simple and majestic.

"Ah! Here is a subject," exclaimed the king, when he saw the little prince coming.

And the little prince asked himself:

"How could he recognize me when he had never seen me before?"

He did not know how the world is simplified for kings. To them, all men are subjects.

"Approach, so that I may see you better, " said the king, who felt consumingly proud of being at last a king over somebody.

The little prince looked everywhere to find a place to sit down; but the entire planet was crammed and obstructed by the king's magnificent ermine robe. So he remained standing upright, and, since he was tired, he yawned.

"It is contrary to etiquette to yawn in the presence of a king," the monarch said to him. "I forbid you to do so."

"I can't help it. I can't stop myself," replied the little prince, thoroughly embarrassed. "I have come on a long journey, and I have had no sleep..."

"Ah, then," the king said. "I order you to yawn. It is years since I have seen anyone yawning. Yawns, to me, are objects of curiosity. Come, now! Yawn again! It is an order."

"That frightens me... I cannot, any more..." murmured the little prince, now completely abashed.

"Hum! Hum!" replied the king. "Then I– I order you sometimes to yawn and sometimes to–"

He sputtered a little, and seemed vexed.

For what the king fundamentally insisted upon was that his authority should be respected. He tolerated no disobedience. He was an absolute monarch. But, because he was a very good man, he made his orders reasonable.

"If I ordered a general," he would say, by way of example, "if I ordered a general to change himself into a sea bird, and if the general did not obey

me, that would not be the fault of the general. It would be my fault."

"May I sit down?" came now a timid inquiry from the little prince.

"I order you to do so," the king answered him, and majestically gathered in a fold of his ermine mantle.

But the little prince was wondering... The planet was tiny. Over what could this king really rule?

"Sire," he said to him, "I beg that you will excuse my asking you a question–"

"I order you to ask me a question," the king hastened to assure him.

"Sire– over what do you rule?"

"Over everything," said the king, with magnificent simplicity.

"Over everything?"

The king made a gesture, which took in his planet, the other planets, and all the stars.

"Over all that?" asked the little prince.

"Over all that," the king answered.

For his rule was not only absolute: it was also universal.

"And the stars obey you?"

"Certainly they do," the king said. "They obey instantly. I do not permit

insubordination."

Such power was a thing for the little prince to marvel at. If he had been master of such complete authority, he would have been able to watch the sunset, not forty-four times in one day, but seventy-two, or even a hundred, or even two hundred times, without ever having to move his chair. And because he felt a bit sad as he remembered his little planet which he had forsaken, he plucked up his courage to ask the king a favor:

"I should like to see a sunset... do me that kindness... Order the sun to set..."

"If I ordered a general to fly from one flower to another like a butterfly, or to write a tragic drama, or to change himself into a sea bird, and if the general did not carry out the order that he had received, which one of us would be in the wrong?" the king demanded. "The general, or myself?"

"You," said the little prince firmly.

"Exactly. One must require from each one the duty which each one can perform," the king went on. "Accepted authority rests first of all on reason. If you ordered your people to go and throw themselves into the sea, they would rise up in revolution. I have the right to require obedience because my orders are reasonable."

"Then my sunset?" the little prince reminded him: for he never forgot a question once he had asked it.

"You shall have your sunset. I shall command it. But, according to my science of government, I shall wait until conditions are favorable."

"When will that be?" inquired the little prince.

"Hum! Hum! " replied the king; and before saying anything else he consulted a bulky almanac. "Hum! Hum! That will be about– about– that will be this evening about twenty minutes to eight. And you will see how well I am obeyed."

The little prince yawned. He was regretting his lost sunset. And then, too, he was already beginning to be a little bored.

"I have nothing more to do here," he said to the king. "So I shall set out on my way again."

"Do not go," said the king, who was very proud of having a subject. "Do not go. I will make you a Minister!"

"Minister of what?"

"Minster of– of Justice!"

"But there is nobody here to judge!"

"We do not know that," the king said to him. "I have not yet made a complete tour of my kingdom. I am very old. There is no room here for a carriage. And it tires me to walk."

"Oh, but I have looked already!" said the little prince, turning around to give one more glance to the other side of the planet. On that side, as on this, there was nobody at all...

"Then you shall judge yourself," the king answered. "that is the most difficult thing of all. It is much more difficult to judge oneself than to judge others. If you succeed in judging yourself rightly, then you are indeed a man of true wisdom."

"Yes," said the little prince, "but I can judge myself anywhere. I do not need to live on this planet."

"Hum! Hum!" said the king. "I have good reason to believe that somewhere on my planet there is an old rat. I hear him at night. You can judge this old rat. From time to time you will condemn him to death. Thus his life will depend on your justice. But you will pardon him on each occasion; for he must be treated thriftily. He is the only one we have."

"I," replied the little prince, "do not like to condemn anyone to death. And now I think I will go on my way."

"No," said the king.

But the little prince, having now completed his preparations for departure, had no wish to grieve the old monarch.

"If Your Majesty wishes to be promptly obeyed," he said, "he should be able to give me a reasonable order. He should be able, for example, to order me to be gone by the end of one minute. It seems to me that conditions are favorable..."

As the king made no answer, the little prince hesitated a moment. Then, with a sigh, he took his leave.

"I made you my Ambassador," the king called out, hastily.

He had a magnificent air of authority.

"The grown-ups are very strange," the little prince said to himself, as he continued on his journey.

Chapter 11

The second planet was inhabited by a conceited man.

"Ah! Ah! I am about to receive a visit from an admirer!" he exclaimed from afar, when he first saw the little prince coming.

For, to conceited men, all other men are admirers.

"Good morning," said the little prince. "That is a queer hat you are wearing."

"It is a hat for salutes," the conceited man replied. "It is to raise in salute when people acclaim me. Unfortunately, nobody at all ever passes this way."

"Yes?" said the little prince, who did not understand what the conceited man was talking about.

"Clap your hands, one against the other," the conceited man now directed him.

The little prince clapped his hands. The conceited man raised his hat in a modest salute.

"This is more entertaining than the visit to the king," the little prince said to himself. And he began again to clap his hands, one against the other. The conceited man again raised his hat in salute.

After five minutes of this exercise the little prince grew tired of the game's monotony.

"And what should one do to make the hat come down?" he asked.

But the conceited man did not hear him. Conceited people never hear anything but praise.

"Do you really admire me very much?" he demanded of the little prince.

"What does that mean– 'admire'?"

"To admire means that you regard me as the handsomest, the best-dressed, the richest, and the most intelligent man on this planet."

"But you are the only man on your planet!"

"Do me this kindness. Admire me just the same."

"I admire you," said the little prince, shrugging his shoulders slightly, "but what is there in that to interest you so much?"

And the little prince went away.

"The grown-ups are certainly very odd," he said to himself, as he continued on his journey.

Chapter 12

The next planet was inhabited by a tippler. This was a very short visit, but it plunged the little prince into deep dejection.

"What are you doing there?" he said to the tippler, whom he found settled down in silence before a collection of empty bottles and also a collection of full bottles.

"I am drinking." replied the tippler, with a lugubrious air.

"Why are you drinking?" demanded the little prince.

"So that I may forget," replied the tippler.

"Forget what?" inquired the little prince, who already was sorry for him.

"Forget that I am ashamed," the tippler confessed, hanging his head.

"Ashamed of what?" insisted the little prince, who wanted to help him.

"Ashamed of drinking!" The tippler brought his speech to an end, and shut himself up in an impregnable silence.

And the little prince went away, puzzled.

"The grown-ups are certainly very, very odd," he said to himself, as he continued on his journey.

Chapter 13

The fourth planet belonged to a businessman. This man was so much occupied that he did not even raise his head at the little prince's arrival.

"Good morning," the little prince said to him. "Your cigarette has gone out."

"Three and two make five. Five and seven make twelve. Twelve and three make fifteen. Good morning. Fifteen and seven make twenty-two.

Twenty-two and six make twenty-eight. I haven't time to light it again. Twenty-six and five make thirty-one. Phew! That makes five-hundred-and-one-million, six-hundred-twenty-two-thousand, seven-hundred-thirty-one."

"Five hundred million what?" asked the little prince.

"Eh? Are you still there? Five-hundred-and-one million– I can't stop... I have so much to do! I am concerned with matters of consequence. I don't amuse myself with balderdash. Two and five make seven..."

"Five-hundred-and-one million what?" repeated the little prince, who never in his life had let go of a question once he had asked it.

The businessman raised his head.

"During the fifty-four years that I have inhabited this planet, I have been disturbed only three times. The first time was twenty-two years ago, when a beetle fell from goodness knows where. He made the most frightful noise that resounded all over the place, and I made four mistakes in my addition. The second time, eleven years ago, I was disturbed by an attack of rheumatism. I don't get enough exercise. I have no time for loafing. The third time—well, this is it! I was saying, then, five -hundred-and-one millions–"

"Millions of what?"

The businessman suddenly realized that there was no hope of being left in peace until he answered this question.

"Millions of those little objects," he said, "which one sometimes sees in the sky."

"Flies? "

"Oh, no. Little glittering objects."

"Bees?"

"Oh, no. Little golden objects that set lazy men to idle dreaming. As for me, I am concerned with matters of consequence. There is no time for idle dreaming in my life. "

"Ah! You mean the stars?"

"Yes, that's it. The stars."

"And what do you do with five-hundred millions of stars?"

"Five-hundred-and-one million, six-hundred-twenty-two thousand, seven-hundred-thirty-one. I am concerned with matters of consequence: I am accurate."

"And what do you do with these stars?"

"What do I do with them?"

"Yes."

"Nothing. I own them."

"You own the stars?"

"Yes. "

"But I have already seen a king who–"

"Kings do not own, they reign over. It is a very different matter. "

"And what good does it do you to own the stars?"

"It does me the good of making me rich."

"And what good does it do you to be rich?"

"It makes it possible for me to buy more stars, if any are ever discovered."

"This man," the little prince said to himself, "reasons a little like my poor tippler... "

Nevertheless, he still had some more questions.

"How is it possible for one to own the stars?"

"To whom do they belong?" the businessman retorted, peevishly.

"I don't know. To nobody."

"Then they belong to me, because I was the first person to think of it."

"Is that all that is necessary?"

"Certainly. When you find a diamond that belongs to nobody, it is yours. When you discover an island that belongs to nobody, it is yours. When you get an idea before anyone else, you take out a patent on it: it is yours. So with me: I own the stars, because nobody else before me ever thought of owning them."

"Yes, that is true," said the little prince. "And what do you do with them?"

"I administer them, " replied the businessman. "I count them and recount

them. It is difficult. But I am a man who is naturally interested in matters of consequence."

The little prince was still not satisfied.

"If I owned a silk scarf," he said, "I could put it around my neck and take it away with me. If I owned a flower, I could pluck that flower and take it away with me. But you cannot pluck the stars from heaven... "

"No. But I can put them in the bank. "

"Whatever does that mean?"

"That means that I write the number of my stars on a little paper. And then I put this paper in a drawer and lock it with a key."

"And that is all?"

"That is enough," said the businessman.

"It is entertaining," thought the little prince. "It is rather poetic. But it is of no great consequence."

On matters of consequence, the little prince had ideas which were very different from those of the grown-ups.

"I myself own a flower," he continued his conversation with the businessman, "which I water every day. I own three volcanoes, which I clean out every week (for I also clean out the one that is extinct; one never knows). It is of some use to my volcanoes, and it is of some use to my flower, that I own them. But you are of no use to the stars..."

The businessman opened his mouth, but he found nothing to say in

answer. And the little prince went away.

"The grown-ups are certainly altogether extraordinary," he said simply, talking to himself as he continued on his journey.

Chapter 14

The fifth planet was very strange. It was the smallest of all. There was just enough room on it for a street lamp and a lamplighter. The little prince was not able to reach any explanation of the use of a street lamp and a lamplighter, somewhere in the heavens, on a planet which had no people, and not one house. But he said to himself, nevertheless:

"It may well be that this man is absurd. But he is not so absurd as the king, the conceited man, the businessman, and the tippler. For at least his work has some meaning. When he lights his street lamp, it is as if he brought one more star to life, or one flower. When he puts out his lamp, he sends the flower, or the star, to sleep. That is a beautiful occupation. And since it is beautiful, it is truly useful."

When he arrived on the planet he respectfully saluted the lamplighter.

"Good morning. Why have you just put out your lamp?"

"Those are the orders," replied the lamplighter. "Good morning."

"What are the orders?"

"The orders are that I put out my lamp. Good evening."

And he lighted his lamp again.

"But why have you just lighted it again?"

"Those are the orders." replied the lamplighter.

"I do not understand." said the little prince.

"There is nothing to understand." said the lamplighter. "Orders are orders. Good morning."

And he put out his lamp.

Then he mopped his forehead with a handkerchief decorated with red squares.

"I follow a terrible profession. In the old days it was reasonable. I put the lamp out in the morning, and in the evening I lighted it again. I had the rest of the day for relaxation and the rest of the night for sleep."

"And the orders have been changed since that time?"

"The orders have not been changed," said the lamplighter. "That is the tragedy! From year to year the planet has turned more rapidly and the orders have not been changed!"

"Then what?" asked the little prince.

"Then– the planet now makes a complete turn every minute, and I no longer have a single second for repose. Once every minute I have to light my lamp and put it out! "

"That is very funny! A day lasts only one minute, here where you live!"

"It is not funny at all!" said the lamplighter. "While we have been talking together a month has gone by."

"A month?"

"Yes, a month. Thirty minutes. Thirty days. Good evening.

And he lighted his lamp again.

As the little prince watched him, he felt that he loved this lamplighter who was so faithful to his orders. He remembered the sunsets which he himself had gone to seek, in other days, merely by pulling up his chair; and he wanted to help his friend."

"You know," he said, "I can tell you a way you can rest whenever you want to..."

"I always want to rest," said the lamplighter.

For it is possible for a man to be faithful and lazy at the same time.

The little prince went on with his explanation:

"Your planet is so small that three strides will take you all the way around it. To be always in the sunshine, you need only walk along rather slowly. When you want to rest, you will walk– and the day will last as long as you like."

"That doesn't do me much good," said the lamplighter. "The one thing I love in life is to sleep."

"Then you're unlucky," said the little prince.

"I am unlucky," said the lamplighter. "Good morning."

And he put out his lamp.

"That man," said the little prince to himself, as he continued farther on his journey, "that man would be scorned by all the others: by the king, by the conceited man, by the tippler, by the businessman. Nevertheless he is the only one of them all who does not seem to me ridiculous. Perhaps that is because he is thinking of something else besides himself."

He breathed a sigh of regret, and said to himself, again:

"That man is the only one of them all whom I could have made my friend. But his planet is indeed too small. There is no room on it for two people..."

What the little prince did not dare confess was that he was sorry most of all to leave this planet, because it was blest every day with 1440 sunsets!

Chapter 15

The sixth planet was ten times larger than the last one. It was inhabited by an old gentleman who wrote voluminous books.

"Oh, look! Here is an explorer!" he exclaimed to himself when he saw the little prince coming.

The little prince sat down on the table and panted a little. He had already traveled so much and so far!

"Where do you come from?" the old gentleman said to him.

"What is that big book?" said the little prince. "What are you doing?"

"I am a geographer," the old gentleman said to him.

"What is a geographer?" asked the little prince.

"A geographer is a scholar who knows the location of all the seas, rivers, towns, mountains, and deserts."

"That is very interesting," said the little prince. "Here at last is a man who has a real profession!" And he cast a look around him at the planet of the geographer. It was the most magnificent and stately planet that he had ever seen.

"Your planet is very beautiful," he said. "Has it any oceans?"

"I couldn't tell you," said the geographer.

"Ah!" The little prince was disappointed. "Has it any mountains?"

"I couldn't tell you," said the geographer.

"And towns, and rivers, and deserts?"

"I couldn't tell you that, either."

"But you are a geographer!"

"Exactly," the geographer said. "But I am not an explorer. I haven't a single explorer on my planet. It is not the geographer who goes out to count the towns, the rivers, the mountains, the seas, the oceans, and the deserts. The geographer is much too important to go loafing about. He does not leave

his desk. But he receives the explorers in his study. He asks them questions, and he notes down what they recall of their travels. And if the recollections of any one among them seem interesting to him, the geographer orders an inquiry into that explorer's moral character."

"Why is that?"

"Because an explorer who told lies would bring disaster on the books of the geographer. So would an explorer who drank too much."

"Why is that?" asked the little prince.

"Because intoxicated men see double. Then the geographer would note down two mountains in a place where there was only one."

"I know someone," said the little prince, "who would make a bad explorer."

"That is possible. Then, when the moral character of the explorer is shown to be good, an inquiry is ordered into his discovery."

"One goes to see it?"

"No. That would be too complicated. But one requires the explorer to furnish proof. For example, if the discovery in question is that of a large mountain, one requires that large stones be brought back from it."

The geographer was suddenly stirred to excitement.

"But you-- you come from far away! You are an explorer! You shall describe your planet to me!"

And, having opened his big register, the geographer sharpened his

pencil. The recitals of explorers are put down first in pencil. One waits until the explorer has furnished proof, before putting them down in ink.

"Well?" said the geographer expectantly.

"Oh, where I live," said the little prince, "it is not very interesting. It is all so small. I have three volcanoes. Two volcanoes are active and the other is extinct. But one never knows."

"One never knows," said the geographer.

"I have also a flower."

"We do not record flowers," said the geographer.

"Why is that? The flower is the most beautiful thing on my planet!"

"We do not record them," said the geographer, "because they are ephemeral."

"What does that mean– 'ephemeral'?"

"Geographies," said the geographer, "are the books which, of all books, are most concerned with matters of consequence. They never become old-fashioned. It is very rarely that a mountain changes its position. It is very rarely that an ocean empties itself of its waters. We write of eternal things."

"But extinct volcanoes may come to life again," the little prince interrupted. "What does that mean– 'ephemeral'?"

"Whether volcanoes are extinct or alive, it comes to the same thing for us," said the geographer. "The thing that matters to us is the mountain. It does not change."

"But what does that mean– 'ephemeral'?" repeated the little prince, who never in his life had let go of a question, once he had asked it.

"It means, 'which is in danger of speedy disappearance.'"

"Is my flower in danger of speedy disappearance?"

"Certainly it is."

"My flower is ephemeral," the little prince said to himself, "and she has only four thorns to defend herself against the world. And I have left her on my planet, all alone! "

That was his first moment of regret. But he took courage once more.

"What place would you advise me to visit now?" he asked.

"The planet Earth," replied the geographer. "It has a good reputation."

And the little prince went away, thinking of his flower.

Chapter 16

So then the seventh planet was the Earth.

The Earth is not just an ordinary planet! One can count, there 111 kings (not forgetting, to be sure, the Negro kings among them), 7000 geographers, 900,000 businessmen, 7,500,000 tipplers, 311,000,000 conceited men– that is to say, about 2,000,000,000 grown-ups.

To give you an idea of the size of the Earth, I will tell you that before the invention of electricity it was necessary to maintain, over the whole of the six continents, a veritable army of 462,511 lamplighters for the street lamps.

Seen from a slight distance, that would make a splendid spectacle. The movements of this army would be regulated like those of the ballet in the opera. First would come the turn of the lamplighters of New Zealand and Australia. Having set their lamps alight, these would go off to sleep. Next, the lamplighters of China and Siberia would enter for their steps in the dance, and then they too would be waved back into the wings. After that would come the turn of the lamplighters of Russia and the Indies; then those of Africa and Europe; then those of South America; then those of North America. And never would they make a mistake in the order of their entry upon the stage. It would be magnificent.

Only the man who was in charge of the single lamp at the North Pole, and his colleague who was responsible for the single lamp at the South Pole- - only these two would live free from toil and care: they would be busy twice a year.

Chapter 17

When one wishes to play the wit, he sometimes wanders a little from the truth. I have not been altogether honest in what I have told you about the lamplighters. And I realize that I run the risk of giving a false idea of our planet to those who do not k now it. Men occupy a very small place upon the Earth. If the two billion inhabitants who people its surface were all to stand upright and somewhat crowded together, as they do for some big public assembly, they could easily be put into one public square twenty miles long and twenty miles wide. All humanity could be piled up on a small Pacific islet.

The grown-ups, to be sure, will not believe you when you tell them that. They imagine that they fill a great deal of space. They fancy themselves as important as the baobabs. You should advise them, then, to make their own calculations. They adore figures, and that will please them. But do not waste your time on this extra task. It is unnecessary. You have, I know, confidence in me.

When the little prince arrived on the Earth, he was very much surprised not to see any people. He was beginning to be afraid he had come to the wrong planet, when a coil of gold, the color of the moonlight, flashed across the sand.

"Good evening," said the little prince courteously.

"Good evening," said the snake.

"What planet is this on which I have come down?" asked the little prince.

"This is the Earth; this is Africa." the snake answered.

"Ah! Then there are no people on the Earth?"

"This is the desert. There are no people in the desert. The Earth is large." said the snake.

The little prince sat down on a stone, and raised his eyes toward the sky.

"I wonder," he said, "whether the stars are set alight in heaven so that one day each one of us may find his own again... Look at my planet. It is right there above us. But how far away it is!"

"It is beautiful," the snake said. "What has brought you here?"

"I have been having some trouble with a flower," said the little prince.

"Ah!" said the snake.

And they were both silent.

"Where are the men?" the little prince at last took up the conversation again. "It is a little lonely in the desert..."

"It is also lonely among men," the snake said.

The little prince gazed at him for a long time.

"You are a funny animal," he said at last. "You are no thicker than a finger..."

"But I am more powerful than the finger of a king," said the snake.

The little prince smiled.

"You are not very powerful. You haven't even any feet. You cannot even travel..."

"I can carry you farther than any ship could take you," said the snake.

He twined himself around the little prince's ankle, like a golden bracelet.

"Whomever I touch, I send back to the earth from whence he came," the snake spoke again. "But you are innocent and true, and you come from a star..."

The little prince made no reply.

"You move me to pity– you are so weak on this Earth made of granite," the snake said. "I can help you, some day, if you grow too homesick for your own planet. I can–"

"Oh! I understand you very well," said the little prince. "But why do you always speak in riddles?"

"I solve them all," said the snake.

And they were both silent.

Chapter 18

The little prince crossed the desert and met with only one flower. It was a flower with three petals, a flower of no account at all.

"Good morning," said the little prince.

"Good morning," said the flower.

"Where are the men?" the little prince asked, politely.

The flower had once seen a caravan passing.

"Men?" she echoed. "I think there are six or seven of them in existence. I saw them, several years ago. But one never knows where to find them. The wind blows them away. They have no roots, and that makes their life very difficult."

"Goodbye," said the little prince.

"Goodbye," said the flower.

Chapter 19

After that, the little prince climbed a high mountain. The only mountains he had ever known were the three volcanoes, which came up to his knees. And he used the extinct volcano as a footstool. "From a mountain as high as this one," he said to himself, "I shall be able to see the whole planet at one glance, and all the people..."

But he saw nothing, save peaks of rock that were sharpened like needles.

"Good morning," he said courteously.

"Good morning– Good morning– Good morning," answered the echo.

"Who are you?" said the little prince.

"Who are you– Who are you– Who are you?" answered the echo.

"Be my friends. I am all alone," he said.

"I am all alone– all alone– all alone," answered the echo.

"What a queer planet!" he thought. "It is altogether dry, and altogether pointed, and altogether harsh and forbidding. And the people have no imagination. They repeat whatever one says to them... On my planet I had a flower; she always was the first to speak..."

Chapter 20

But it happened that after walking for a long time through sand, and rocks, and snow, the little prince at last came upon a road. And all roads lead to the abodes of men.

"Good morning," he said.

He was standing before a garden, all abloom with roses.

"Good morning," said the roses.

The little prince gazed at them. They all looked like his flower.

"Who are you?" he demanded, thunderstruck.

"We are roses," the roses said.

And he was overcome with sadness. His flower had told him that she was the only one of her kind in all the universe. And here were five thousand of them, all alike, in one single garden!

"She would be very much annoyed," he said to himself, "if she should see that... she would cough most dreadfully, and she would pretend that she was dying, to avoid being laughed at. And I should be obliged to pretend that I was nursing her back to life– for if I did not do that, to humble myself also, she would really allow herself to die..."

Then he went on with his reflections: "I thought that I was rich, with a flower that was unique in all the world; and all I had was a common rose. A common rose, and three volcanoes that come up to my knees– and one of them perhaps extinct forever... that doesn't make me a very great prince..."

And he lay down in the grass and cried.

Chapter 21

It was then that the fox appeared.

"Good morning," said the fox.

"Good morning," the little prince responded politely, although when he turned around he saw nothing.

"I am right here," the voice said, under the apple tree.

"Who are you?" asked the little prince, and added, "You are very pretty to look at."

"I am a fox," said the fox.

"Come and play with me," proposed the little prince. "I am so unhappy."

"I cannot play with you," the fox said. "I am not tamed."

"Ah! Please excuse me," said the little prince.

But, after some thought, he added:

"What does that mean– 'tame'?"

"You do not live here," said the fox. "What is it that you are looking for?"

"I am looking for men," said the little prince. "What does that mean-- 'tame'?"

"Men," said the fox. "They have guns, and they hunt. It is very disturbing. They also raise chickens. These are their only interests. Are you looking for chickens?"

"No," said the little prince. "I am looking for friends. What does that mean- - 'tame'?"

"It is an act too often neglected," said the fox. "It means to establish ties."

"'To establish ties'?"

"Just that," said the fox. "To me, you are still nothing more than a little boy who is just like a hundred thousand other little boys. And I have no need of you. And you, on your part, have no need of me. To you, I am nothing more than a fox like a hundred thousand other foxes. But if you tame me, then we shall need each other. To me, you will be unique in all the world. To you, I shall be unique in all the world..."

"I am beginning to understand," said the little prince. "There is a flower... I think that she has tamed me..."

"It is possible," said the fox. "On the Earth one sees all sorts of things."

"Oh, but this is not on the Earth!" said the little prince.

The fox seemed perplexed, and very curious.

"On another planet?"

"Yes."

"Are there hunters on this planet?"

"No."

"Ah, that is interesting! Are there chickens?"

"No."

"Nothing is perfect," sighed the fox.

But he came back to his idea.

"My life is very monotonous," the fox said. "I hunt chickens; men hunt me. All the chickens are just alike, and all the men are just alike. And, in consequence, I am a little bored. But if you tame me, it will be as if the sun came to shine on my life . I shall know the sound of a step that will be different from all the others. Other steps send me hurrying back underneath the ground. Yours will call me, like music, out of my burrow. And then look: you see the grain-fields down yonder? I do not eat bread. Wheat is of no use to me. The wheat fields have nothing to say to me. And that is sad. But you have hair that is the colour of gold. Think how wonderful that will be when you have tamed me! The grain, which is also golden, will bring me back the thought of you. And I shall love to listen to the wind in the wheat..."

The fox gazed at the little prince, for a long time.

"Please– tame me!" he said.

"I want to, very much," the little prince replied. "But I have not much time. I have friends to discover, and a great many things to understand."

"One only understands the things that one tames," said the fox. "Men

have no more time to understand anything. They buy things all ready made at the shops. But there is no shop anywhere where one can buy friendship, and so men have no friends any more. If you want a friend, tame me..."

"What must I do, to tame you?" asked the little prince.

"You must be very patient," replied the fox. "First you will sit down at a little distance from me– like that– in the grass. I shall look at you out of the corner of my eye, and you will say nothing. Words are the source of misunderstandings. But you will sit a little closer to me, every day..."

The next day the little prince came back.

"It would have been better to come back at the same hour," said the fox. "If, for example, you come at four o'clock in the afternoon, then at three o'clock I shall begin to be happy. I shall feel happier and happier as the hour advances. At four o'clock, I shall already be worrying and jumping about. I shall show you how happy I am! But if you come at just any time, I shall never know at what hour my heart is to be ready to greet you... One must observe the proper rites..."

"What is a rite?" asked the little prince.

"Those also are actions too often neglected," said the fox. "They are what make one day different from other days, one hour from other hours. There is a rite, for example, among my hunters. Every Thursday they dance with the village girls. So Thursday is a wonderful day for me! I can take a walk as far as the vineyards. But if the hunters danced at just any time, every day would be like every other day, and I should never have any vacation at all."

So the little prince tamed the fox. And when the hour of his departure drew near–

"Ah," said the fox, "I shall cry."

"It is your own fault," said the little prince. "I never wished you any sort of harm; but you wanted me to tame you..."

"Yes, that is so," said the fox.

"But now you are going to cry!" said the little prince.

"Yes, that is so," said the fox.

"Then it has done you no good at all!"

"It has done me good," said the fox, "because of the color of the wheat fields." And then he added:

"Go and look again at the roses. You will understand now that yours is unique in all the world. Then come back to say goodbye to me, and I will make you a present of a secret."

The little prince went away, to look again at the roses.

"You are not at all like my rose," he said. "As yet you are nothing. No one has tamed you, and you have tamed no one. You are like my fox when I first knew him. He was only a fox like a hundred thousand other foxes. But I have made him my friend, and now he is unique in all the world."

And the roses were very much embarrassed.

"You are beautiful, but you are empty," he went on. "One could not die for you. To be sure, an ordinary passerby would think that my rose looked just like you– the rose that belongs to me. But in herself alone she is more important than all the hundreds of you other roses: because it is she that

I have watered; because it is she that I have put under the glass globe; because it is she that I have sheltered behind the screen; because it is for her that I have killed the caterpillars (except the two or three that we saved to become butterflies); because it is she that I have listened to, when she grumbled, or boasted, or even sometimes when she said nothing. Because she is my rose."

And he went back to meet the fox.

"Goodbye," he said.

"Goodbye," said the fox. "And now here is my secret, a very simple secret: It is only with the heart that one can see rightly; what is essential is invisible to the eye."

"What is essential is invisible to the eye," the little prince repeated, so that he would be sure to remember.

"It is the time you have wasted for your rose that makes your rose so important."

"It is the time I have wasted for my rose– " said the little prince, so that he would be sure to remember.

"Men have forgotten this truth," said the fox. "But you must not forget it. You become responsible, forever, for what you have tamed. You are responsible for your rose..."

"I am responsible for my rose," the little prince repeated, so that he would be sure to remember.

Chapter 22

"Good morning," said the little prince.

"Good morning," said the railway switchman.

"What do you do here?" the little prince asked.

"I sort out travelers, in bundles of a thousand," said the switchman. "I send off the trains that carry them; now to the right, now to the left."

And a brilliantly lighted express train shook the switchman's cabin as it rushed by with a roar like thunder.

"They are in a great hurry," said the little prince. "What are they looking for?"

"Not even the locomotive engineer knows that," said the switchman.

And a second brilliantly lighted express thundered by, in the opposite direction.

"Are they coming back already?" demanded the little prince.

"These are not the same ones," said the switchman. "It is an exchange."

"Were they not satisfied where they were?" asked the little prince.

"No one is ever satisfied where he is," said the switchman.

And they heard the roaring thunder of a third brilliantly lighted express.

"Are they pursuing the first travelers?" demanded the little prince.

"They are pursuing nothing at all," said the switchman. "They are asleep in there, or if they are not asleep they are yawning. Only the children are flattening their noses against the windowpanes."

"Only the children know what they are looking for," said the little prince. "They waste their time over a rag doll and it becomes very important to them; and if anybody takes it away from them, they cry..."

"They are lucky," the switchman said.

Chapter 23

"Good morning," said the little prince.

"Good morning," said the merchant.

This was a merchant who sold pills that had been invented to quench thirst. You need only swallow one pill a week, and you would feel no need of anything to drink.

"Why are you selling those?" asked the little prince.

"Because they save a tremendous amount of time," said the merchant. "Computations have been made by experts. With these pills, you save fifty-three minutes in every week."

"And what do I do with those fifty-three minutes?"

"Anything you like..."

"As for me," said the little prince to himself, "if I had fifty-three minutes to spend as I liked, I should walk at my leisure toward a spring of fresh water."

Chapter 24

It was now the eighth day since I had had my accident in the desert, and I had listened to the story of the merchant as I was drinking the last drop of my water supply.

"Ah," I said to the little prince, "these memories of yours are very charming; but I have not yet succeeded in repairing my plane; I have nothing more to drink; and I, too, should be very happy if I could walk at my leisure toward a spring of fresh water!"

"My friend the fox–" the little prince said to me.

"My dear little man, this is no longer a matter that has anything to do with the fox!"

"Why not?"

"Because I am about to die of thirst..."

He did not follow my reasoning, and he answered me:

"It is a good thing to have had a friend, even if one is about to die. I, for instance, am very glad to have had a fox as a friend..."

"He has no way of guessing the danger," I said to myself. "He has never been either hungry or thirsty. A little sunshine is all he needs..."

But he looked at me steadily, and replied to my thought:

"I am thirsty, too. Let us look for a well..."

I made a gesture of weariness. It is absurd to look for a well, at random, in the immensity of the desert. But nevertheless we started walking.

When we had trudged along for several hours, in silence, the darkness fell, and the stars began to come out. Thirst had made me a little feverish, and I looked at them as if I were in a dream. The little prince's last words came reeling back into my memory:

"Then you are thirsty, too?" I demanded.

But he did not reply to my question. He merely said to me:

"Water may also be good for the heart..."

I did not understand this answer, but I said nothing. I knew very well that it was impossible to cross-examine him.

He was tired. He sat down. I sat down beside him. And, after a little silence, he spoke again:

"The stars are beautiful, because of a flower that cannot be seen."

I replied, "Yes, that is so." And, without saying anything more, I looked across the ridges of sand that were stretched out before us in the moonlight.

"The desert is beautiful," the little prince added.

And that was true. I have always loved the desert. One sits down on

a desert sand dune, sees nothing, hears nothing. Yet through the silence something throbs, and gleams...

"What makes the desert beautiful," said the little prince, "is that somewhere it hides a well..."

I was astonished by a sudden understanding of that mysterious radiation of the sands. When I was a little boy I lived in an old house, and legend told us that a treasure was buried there. To be sure, no one had ever known how to find it; perhaps no one had ever even looked for it. But it cast an enchantment over that house. My home was hiding a secret in the depths of its heart...

"Yes," I said to the little prince. "The house, the stars, the desert– what gives them their beauty is something that is invisible!"

"I am glad," he said, "that you agree with my fox."

As the little prince dropped off to sleep, I took him in my arms and set out walking once more. I felt deeply moved, and stirred. It seemed to me that I was carrying a very fragile treasure. It seemed to me, even, that there was nothing more fragile on all Earth. In the moonlight I looked at his pale forehead, his closed eyes, his locks of hair that trembled in the wind, and I said to myself: "What I see here is nothing but a shell. What is most important is invisible..."

As his lips opened slightly with a suspicious half-smile, I said to myself, again: "What moves me so deeply, about this little prince who is sleeping here, is his loyalty to a flower– the image of a rose that shines through his whole being like the flame of a lamp, even when he is asleep..." And I felt him to be more fragile still. I felt the need of protecting him, as if he himself were a flame that might be extinguished by a little puff of wind...

And, as I walked on so, I found the well, at daybreak.

Chapter 25

"Men," said the little prince, "set out on their way in express trains, but they do not know what they are looking for. Then they rush about, and get excited, and turn round and round..."

And he added:

"It is not worth the trouble..."

The well that we had come to was not like the wells of the Sahara. The wells of the Sahara are mere holes dug in the sand. This one was like a well in a village. But there was no village here, and I thought I must be dreaming...

"It is strange," I said to the little prince. "Everything is ready for use: the pulley, the bucket, the rope..."

He laughed, touched the rope, and set the pulley to working. And the pulley moaned, like an old weathervane which the wind has long since forgotten.

"Do you hear?" said the little prince. "We have wakened the well, and it is singing..."

I did not want him to tire himself with the rope.

"Leave it to me," I said. "It is too heavy for you."

I hoisted the bucket slowly to the edge of the well and set it there—

happy, tired as I was, over my achievement. The song of the pulley was still in my ears, and I could see the sunlight shimmer in the still trembling water.

"I am thirsty for this water," said the little prince. "Give me some of it to drink..."

And I understood what he had been looking for.

I raised the bucket to his lips. He drank, his eyes closed. It was as sweet as some special festival treat. This water was indeed a different thing from ordinary nourishment. Its sweetness was born of the walk under the stars, the song of the pulley, the effort of my arms. It was good for the heart, like a present. When I was a little boy, the lights of the Christmas tree, the music of the Midnight Mass, the tenderness of smiling faces, used to make up, so, the radiance of the gifts I received.

"The men where you live," said the little prince, "raise five thousand roses in the same garden– and they do not find in it what they are looking for."

"They do not find it," I replied.

"And yet what they are looking for could be found in one single rose, or in a little water."

"Yes, that is true," I said.

And the little prince added:

"But the eyes are blind. One must look with the heart..."

I had drunk the water. I breathed easily. At sunrise the sand is the color of honey. And that honey color was making me happy, too. What brought me, then, this sense of grief?

"You must keep your promise," said the little prince, softly, as he sat down beside me once more.

"What promise?"

"You know– a muzzle for my sheep... I am responsible for this flower..."

I took my rough drafts of drawings out of my pocket. The little prince looked them over, and laughed as he said:

"Your baobabs– they look a little like cabbages."

"Oh!"

I had been so proud of my baobabs!

"Your fox– his ears look a little like horns; and they are too long."

And he laughed again.

"You are not fair, little prince," I said. "I don't know how to draw anything except boa constrictors from the outside and boa constrictors from the inside."

"Oh, that will be all right," he said, "children understand."

So then I made a pencil sketch of a muzzle. And as I gave it to him my heart was torn.

"You have plans that I do not know about," I said.

But he did not answer me. He said to me, instead:

"You know– my descent to the earth... Tomorrow will be its anniversary."

Then, after a silence, he went on:

"I came down very near here."

And he flushed.

And once again, without understanding why, I had a queer sense of sorrow. One question, however, occurred to me:

"Then it was not by chance that on the morning when I first met you-- a week ago– you were strolling along like that, all alone, a thousand miles from any inhabited region? You were on your back to the place where you landed?"

The little prince flushed again.

And I added, with some hesitancy:

"Perhaps it was because of the anniversary?"

The little prince flushed once more. He never answered questions– but when one flushes does that not mean "Yes"?

"Ah," I said to him, "I am a little frightened–"

But he interrupted me.

"Now you must work. You must return to your engine. I will be waiting for you here. Come back tomorrow evening..."

But I was not reassured. I remembered the fox. One runs the risk of weeping a little, if one lets himself be tamed...

Chapter 26

Beside the well there was the ruin of an old stone wall. When I came back from my work, the next evening, I saw from some distance away my little price sitting on top of a wall, with his feet dangling. And I heard him say:

"Then you don't remember. This is not the exact spot."

Another voice must have answered him, for he replied to it:

"Yes, yes! It is the right day, but this is not the place."

I continued my walk toward the wall. At no time did I see or hear anyone. The little prince, however, replied once again:

" Exactly. You will see where my track begins, in the sand. You have nothing to do but wait for me there. I shall be there tonight."

I was only twenty metres from the wall, and I still saw nothing.

After a silence the little prince spoke again:

"You have good poison? You are sure that it will not make me suffer too long?"

I stopped in my tracks, my heart torn asunder; but still I did not understand.

"Now go away," said the little prince. "I want to get down from the wall."

I dropped my eyes, then, to the foot of the wall– and I leaped into the air. There before me, facing the little prince, was one of those yellow snakes that take just thirty seconds to bring your life to an end. Even as I was digging into my pocket to get out my revolver I made a running step back. But, at the noise I made, the snake let himself flow easily across the sand like the dying spray of a fountain, and, in no apparent hurry, disappeared, with a light metallic sound, among the stones.

I reached the wall just in time to catch my little man in my arms; his face was white as snow.

"What does this mean?" I demanded. "Why are you talking with snakes?"

I had loosened the golden muffler that he always wore. I had moistened his temples, and had given him some water to drink. And now I did not dare ask him any more questions. He looked at me very gravely, and put his arms around my neck. I felt his heart beating like the heart of a dying bird, shot with someone's rifle...

"I am glad that you have found what was the matter with your engine," he said. "Now you can go back home–"

"How do you know about that?"

I was just coming to tell him that my work had been successful, beyond anything that I had dared to hope.

He made no answer to my question, but he added:

"I, too, am going back home today..."

Then, sadly–

"It is much farther... it is much more difficult..."

I realized clearly that something extraordinary was happening. I was holding him close in my arms as if he were a little child; and yet it seemed to me that he was rushing headlong toward an abyss from which I could do nothing to restrain him...

His look was very serious, like someone lost far away.

"I have your sheep. And I have the sheep's box. And I have the muzzle..."

And he gave me a sad smile.

I waited a long time. I could see that he was reviving little by little.

"Dear little man," I said to him, "you are afraid..."

He was afraid, there was no doubt about that. But he laughed lightly.

"I shall be much more afraid this evening..."

Once again I felt myself frozen by the sense of something irreparable. And I knew that I could not bear the thought of never hearing that laughter anymore. For me, it was like a spring of fresh water in the desert.

"Little man," I said, "I want to hear you laugh again."

But he said to me:

"Tonight, it will be a year... my star, then, can be found right above the place where I came to the Earth, a year ago..."

"Little man," I said, "tell me that it is only a bad dream– this affair of the snake, and the meeting-place, and the star..."

But he did not answer my plea. He said to me, instead: "The thing that is important is the thing that is not seen..."

"Yes, I know..."

"It is just as it is with the flower. If you love a flower that lives on a star, it is sweet to look at the sky at night. All the stars are abloom with flowers..."

"Yes, I know..."

"It is just as it is with the water. Because of the pulley, and the rope, what you gave me to drink was like music. You remember– how good it was."

"Yes, I know..."

"And at night you will look up at the stars. Where I live everything is so small that I cannot show you where my star is to be found. It is better, like that. My star will just be one of the stars, for you. And so you will love to watch all the stars in the heavens... they will all be your friends. And, besides, I am going to make you a present..."

He laughed again.

"Ah, little prince, dear little prince! I love to hear that laughter!"

"That is my present. Just that. It will be as it was when we drank the water..."

"What are you trying to say?"

"All men have the stars," he answered, "but they are not the same things for different people. For some, who are travelers, the stars are guides. For others they are no more than little lights in the sky. For others, who are scholars, they are problems. For my businessman they are wealth. But all these stars are silent. You– you alone– will have the stars as no one else has them–

"What are you trying to say?"

"In one of the stars I shall be living. In one of them I shall be laughing. And so it will be as if all the stars were laughing, when you look at the sky at night... you– only you– will have stars that can laugh! "

And he laughed again.

"And when your sorrow is comforted (time soothes all sorrows) you will be content that you have known me. You will always be my friend. You will want to laugh with me. And you will sometimes open your window, so, for that pleasure... and your friends will be properly astonished to see you laughing as you look up at the sky! Then you will say to them, 'Yes, the stars always make me laugh!' And they will think you are crazy. It will be a very shabby trick that I shall have played on you..."

And he laughed again.

"It will be as if, in place of the stars, I had given you a great number of little bells that knew how to laugh..."

And he laughed again. Then he quickly became serious:

"Tonight– you know... do not come," said the little prince.

"I shall not leave you," I said.

"I shall look as if I were suffering. I shall look a little as if I were dying. It is like that. Do not come to see that. It is not worth the trouble..."

"I shall not leave you."

But he was worried.

"I tell you– it is also because of the snake. He must not bite you. Snakes– they are malicious creatures. This one might bite you just for fun..."

"I shall not leave you."

But a thought came to reassure him:

"It is true that they have no more poison for a second bite."

That night I did not see him set out on his way. He got away from me without making a sound. When I succeeded in catching up with him, he was walking along with a quick and resolute step. He said to me merely:

"Ah! You are there..."

And he took me by the hand. But he was still worrying.

"It was wrong of you to come. You will suffer. I shall look as if I were dead; and that will not be true..."

I said nothing.

"You understand... it is too far. I cannot carry this body with me. It is too heavy."

I said nothing.

"But it will be like an old abandoned shell. There is nothing sad about old shells..."

I said nothing.

He was a little discouraged. But he made one more effort:

"You know, it will be very nice. I, too, shall look at the stars. All the stars will be wells with a rusty pulley. All the stars will pour out fresh water for me to drink..."

I said nothing.

"That will be so amusing! You will have five hundred million little bells, and I shall have five hundred million springs of fresh water..."

And he, too, said nothing more, because he was crying...

"Here it is. Let me go on by myself."

And he sat down, because he was afraid. Then he said, again:

"You know– my flower... I am responsible for her. And she is so weak! She is so naive! She has four thorns, of no use at all, to protect herself against all the world..."

I, too, sat down, because I was not able to stand up any longer.

"There now– that is all..."

He still hesitated a little; then he got up. He took one step. I could not move.

There was nothing but a flash of yellow close to his ankle. He remained motionless for an instant. He did not cry out. He fell as gently as a tree falls. There was not even any sound, because of the sand.

Chapter 27

And now six years have already gone by...

I have never yet told this story. The companions who met me on my return were well content to see me alive. I was sad, but I told them: "I am tired."

Now my sorrow is comforted a little. That is to say– not entirely. But I know that he did go back to his planet, because I did not find his body at daybreak. It was not such a heavy body... and at night I love to listen to the stars. It is like five hundred million little bells...

But there is one extraordinary thing... when I drew the muzzle for the little prince, I forgot to add the leather strap to it. He will never have been able to fasten it on his sheep. So now I keep wondering: what is happening on his planet? Perhaps the sheep has eaten the flower...

At one time I said to myself: "Surely not! The little prince shuts his flower under her glass globe every night, and he watches over his sheep very carefully..." Then I am happy. And there is sweetness in the laughter of all the stars.

But at another time I said to myself: "At some moment or other one is

absent-minded, and that is enough! On some one evening he forgot the glass globe, or the sheep got out, without making any noise, in the night..." And then the little bells are changed to tears...

Here, then, is a great mystery. For you who also love the little prince, and for me, nothing in the universe can be the same if somewhere, we do not know where, a sheep that we never saw has– yes or no?– eaten a rose...

Look up at the sky. Ask yourselves: is it yes or no? Has the sheep eaten the flower? And you will see how everything changes...

And no grown-up will ever understand that this is a matter of so much importance!

This is, to me, the loveliest and saddest landscape in the world. It is the same as that on the preceding page, but I have drawn it again to impress it on your memory. It is here that the little prince appeared on Earth, and disappeared.

Look at it carefully so that you will be sure to recognize it in case you travel someday to the African desert. And, if you should come upon this spot, please do not hurry on. Wait for a time, exactly under the star. Then, if a little man appears who laughs, who has golden hair and who refuses to answer questions, you will know who he is. If this should happen, please comfort me. Send me word that he has come back.

國家圖書館出版品預行編目資料

Le Petit Prince小王子行星漫遊著色本（中英
文版）/ 安東尼・聖修伯里作；
　Bunny繪. -- 初版. --新北市：世潮, 2015.11
　　面；公分. - -（好時光；2）
　　中英文版
　　譯自：Le petit prince
　　ISBN 978-986-259-039-3（平裝）

　　1.繪畫　　2.畫冊

947.5　　　　　　　　　　　　　104019455

好時光 02

Le Petit Prine小王子
行星漫遊著色本（中英文版）

作　　者／安東尼 ・ 聖修伯里

繪　　者／Bunny

譯　　者／葉實琥

主　　編／簡玉芬

責任編輯／石文穎

出 版 者／世潮出版有限公司

發 行 人／簡玉芳

地　　址／(231) 新北市新店區民生路 19 號 5 樓

電　　話／(02)2218-3277

傳　　真／(02)2218-3239（訂書專線）、(02)2218-7539

劃撥帳號／17528093

戶　　名／世潮出版有限公司
　　　　　　單次郵購總金額未滿 500 元（含），請加 50 元掛號費

世茂官網／www.coolbooks.com.tw

排版製版／辰皓國際出版製作有限公司

印　　刷／祥新印刷事業股份有限公司

初版一刷／2015 年 11 月

I S B N／978-986-259-039-3

定　　價／380 元

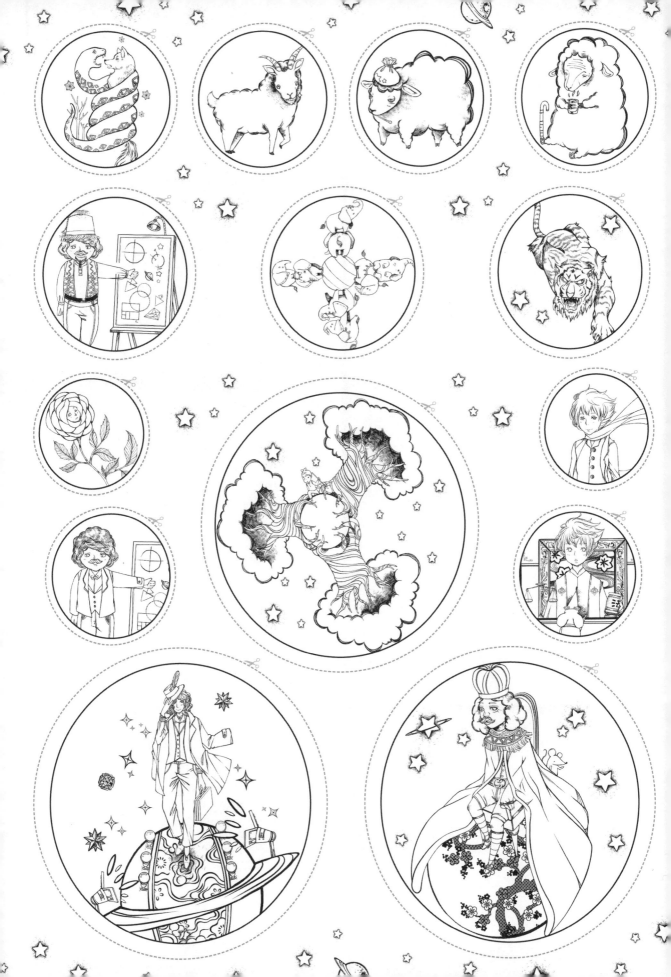